IMAGES
of America

ALONG THE RARITAN RIVER
FROM SOUTH AMBOY TO NEW BRUNSWICK

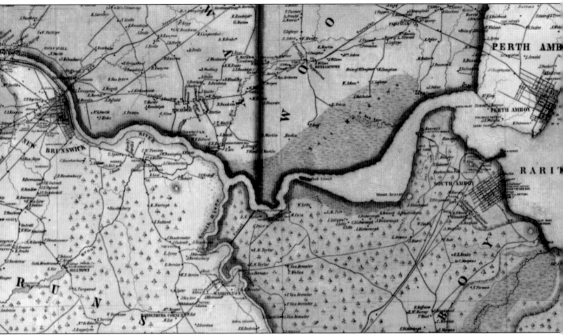

In 1850, the lower Raritan River was the center of activity in Middlesex County. From Colonial times, villages, towns, and cities flourished on its banks. Farmers, merchants, artisans, industrialists, and laborers alike all benefited from and relied upon the Raritan; it was the economic lifeblood of the entire region. It was also the center of culture, from which news spread and information was given and received. Of Middlesex County's 28,000 residents, half of them lived in either the Amboys or New Brunswick, the county's largest city by far with over 10,000 residents alone. Outside of these cities, the landscape was still rural, covered mostly by forests with extensive salt marshes along the banks of river. The river made this a desirable place to live, and thanks to the prosperity it brought the region, Middlesex County is today home to over 820,000 people. (Courtesy of the Sayreville Historical Society.)

ON THE COVER: The most unique geographical feature of the lower Raritan River is an oxbow located three miles inland and known as "the Roundabout." A constant flow of schooners and barges transported shipments of bricks from the docks here and along the South River and Washington Canal. Steamboats transported people along the Raritan, too, such as the *New Brunswick*, pictured here, which made daily trips between New Brunswick and New York City. (Courtesy of the Sayreville Historical Society.)

IMAGES
of America

ALONG THE RARITAN RIVER
FROM SOUTH AMBOY TO NEW BRUNSWICK

Jason J. Slesinski

ARCADIA
PUBLISHING

Published by Arcadia Publishing
Charleston, South Carolina

Printed in the United States of America

Library of Congress Control Number: 2013951310

For all general information, please contact Arcadia Publishing:
Telephone 843-853-2070
Fax 843-853-0044
E-mail sales@arcadiapublishing.com
For customer service and orders:
Toll-Free 1-888-313-2665

Visit us on the Internet at www.arcadiapublishing.com

To Marian and Joe, "Grandma and Poppop with the Boats"

CONTENTS

ACKNOWLEDGMENTS

I would like to thank the many institutions and individuals who have assisted me in the compilation of images for this book. Bob Belvin at the New Brunswick Free Public Library gave me my first introduction to the visual history of the river in New Brunswick, without which this book would not have been possible. The South River Historical & Preservation Society was, and continues to be, an impressive and admirable institution, and I would like to thank Brian Armstrong, Nan Whitehead, and particularly Stephanie Bartz for her generous assistance.

I would also like to thank Mary Szaro, president of the Historical Society of South Amboy, and Alycia Rihacek, president of the Madison Township Historical Society at the Thomas Warne Museum. John Kerry Dyke provided me with not only images of Perth Amboy, but also with research for which I am most grateful. I would also like to thank Verne James, whose assistance in the writing of this book was invaluable and whose efforts to preserve and share the history of Morgan are an inspiration to me. Many thanks to James Creed, without whose images this story would be incomplete.

The Sayreville Historical Society deserves a special acknowledgement for their assistance and continued support, especially Art Rittenhouse and Al Baumann, to whom I am continually grateful. I would also like to thank Bill Schultz, the Raritan Riverkeeper, not only for his indispensable assistance with this book, but also for all of the selfless work he has done, and continues to do, to ensure that the Raritan River is restored for the benefit and enjoyment of future generations. Without people like him, the trajectory of the story told in this book would be much different.

Last, but certainly not least, a heartfelt thanks to my family for their continued support of my work, and to Ithan Sokol, for his limitless patience and encouragement.

INTRODUCTION

In 1650, Cornelius van Tienhoven, a Hollander traveling through the American colonies, described the region inhabited by the Raritong Indians as "the pleasantest and handsomest country that man can behold . . . furnishing the Indians with abundance of maize, beans, pumpkins, and other fruits." Trade flourished here as well, as "through the valley pass large numbers of all sorts of tribes, on the way north or east." Worn over the centuries, the "Old Indian Path" crossed the Raritan at its farthest point of sloop navigation and grew into one of the nation's busiest arteries, connecting New York City and Philadelphia via New Brunswick, which developed around this vital river crossing.

A ferry was first established here in 1681 by an Englishman named John Inian, where the Raritan's freshwater turned tidal. Bridges followed, firmly establishing the route of the New Jersey Turnpike, Route 1, the Lincoln Highway, and Amtrak's Northeast Corridor. George Washington crossed the Raritan River here with his army many times during the American Revolution, both in victory and defeat. At the other end of the lower Raritan, a place the Lenape called Ompoye, Colonial Scottish investors envisioned a second London, a fortified deepwater port city that would outshine New York City. They called it "the City of Perth."

In 1684, Andrew Radford began operating a ferry to Perth from the "Outer Plantations" on the south bank of the Raritan, establishing the first link between the Amboys. It took a railroad bridge 200 years later to finally end the ferry service. Then, in the 20th century, the Edison Bridge, followed by its sister bridge, the Driscoll, rose over 250 feet above the river, expanding together over time to become the world's widest bridge and one of its busiest. By the dawn of the Industrial Revolution, New Brunswick and the Amboys were the economic, commercial, and cultural hubs of the lower Raritan River, and their early history was marked by continual competition. As is the case today, anyone traveling between New York and Philadelphia had to cross the Raritan River, and both cities were eager to gain control of that route.

The Industrial Revolution brought steamboats to the Raritan. While before, South Amboy and New Brunswick competed to attract travelers to their ferries from the dirt roads that led to the river, the steam age gave both ports a direct link to New York City, but not without the help of the Supreme Court. Fighting to overturn a steamboat monopoly on New York's waters, the legendary tycoon Cornelius Vanderbilt flew flags from his steamers in the Raritan that read "New Jersey Must Be Free!" until the landmark Supreme Court ruling in *Gibbons v. Ogden* opened New York's waters to interstate commerce. Vanderbilt then settled in New Brunswick with his wife, where she ran a popular hotel while he captained steamers up and down the Raritan, promoting that city as the transfer point between steamboats to New York and stagecoaches to Philadelphia.

In 1833, the first train whistle blew in South Amboy, and the once quiet hamlet on the Raritan would never be the same. New Jersey's first railroad, the Camden & Amboy, transformed the small ferry port town into a boisterous freight and shipping center. More railroads would follow, and by the close of the 19th century, South Amboy's waterfront was filled with coal cars from the anthracite fields of Pennsylvania, Maryland, and West Virginia, ready to be loaded into barges waiting in the Raritan. In the mid-19th century, massive clay deposits along the river between that city and New Brunswick drew thousands of immigrant workers into the brickyards of South River and Sayreville, where the Sayre & Fisher Brick Company steadily grew into the largest brick manufacturer in the world, owing its success to the transportation the river offered and the seemingly limitless natural resource found in its banks: clay. Industries of nearly every kind flourished along the Raritan because of its easy access to an abundant water supply, and the blessings of geography were bolstered by a competitive transportation network, which put the Raritan River in close contact with many of the nation's largest markets.

The economic prosperity that the Raritan brought to the region was, however, threatened by the very industries the river brought to life. For over a century, the river was used as, in the words of the Raritan Riverkeeper, an "industrial garbage can." The uncontrolled and accelerated disposal of industrial toxic waste in the river, coupled with an unregulated flow of sewage from a continually growing population, turned the once pristine river into an acute threat to public health and safety. By the 1920s, the once alluring and majestic river was all but destroyed, with its waters dimmed by waste and its banks poisoned by trash and vile odors. Once home to a robust fishing industry, fish and shellfish populations were decimated, and what remained was no longer safe for human consumption. In 1997, the Raritan was ranked the 14th-most polluted river in the United States, with over 200 contaminated sites in its watershed, 24 of them federally designated superfund sites.

I have lived near the Raritan and South Rivers all my life. And while the circumstances of time have forbidden me from swimming in the Raritan like so many before me, I have fished, crabbed, kayaked, and sailed these waters, and, in doing so, encountered "riverscapes" both breathtaking and heartbreaking. I have witnessed firsthand what we have done to the Raritan, and I have also seen what it has done to us, when it has suddenly flooded its banks and forced its way into our streets and our homes. I wrote this book firstly to explore how the Raritan has shaped our local history and what it has meant to all those who have lived beside its tidal waters, but I also wrote it to offer questions about our relationship with the river—what it was and what it could be. Whether knowingly or not, the Raritan River has shaped the lives of countless millions of people. It has been both conquered and cherished, exploited and admired, ignored and fought for, and, whether we acknowledge it or not, we are all stewards of the Raritan.

One evening in the winter of 1806, while visiting a friend in America, an Englishman named John Davis sat beside the Raritan appreciating the graceful, immutable flow of its blue waters. His thoughts drifted to the Lenape, the very first stewards of the river, and he envisioned a lone "naked, native son" feeling just as he did that night, affected and overcome with awe and respect for the gentle, timeless song of the river. So inspired, he wrote "Ode to the Raritan River," which was published in London's *European Magazine* in May 1806, and thus bestowed upon the Raritan a moniker that will forever be linked to this exception river:

And oft, perhaps, beside the flood,
In darkness of the grove he stood;

Invoking here thy friendly aid
To guide him thro' the doubtful shade:

Till overhead the moon in View
Thro' heaven's blue fields the chariot drew,

And show'd him all thy wat'ry face,
Reflected with a purer grace;

Thy many turnings thro' the trees,
Thy bitter journey to the Seas.

While oft thy murmurs loud and long
Awak'd his melancholy song;

Which thus in simple strain began,
"Thou Queen of Rivers, Raritan!"

One

QUEEN OF RIVERS

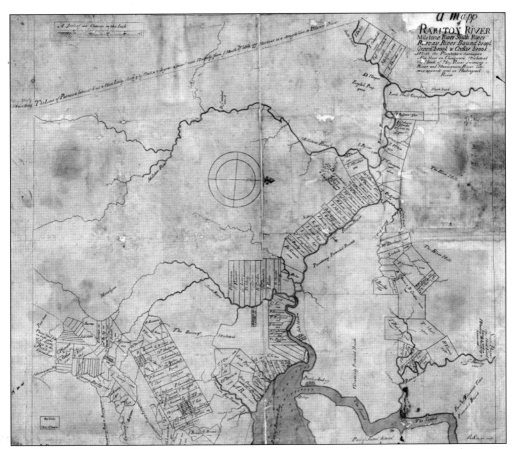

In 1524, the Florentine Giovanni da Verrazano explored the mouth of the Raritan River for Spain, followed by Henry Hudson who sailed into the river in 1609 in his ship the *Half Moon* and claimed the land for the Dutch East India Company. Early European explorers encountered a coastline littered with large oyster shells and a handsome and fertile countryside marked by salt marshes, meadows, and forests of pine, oak, chestnut, and hickory. The Dutch remained in control of the Raritan, which they named for the Raritong tribe who they had encountered on the riverbanks, until 1664, when it fell into the hands of the British. After taking control of New Netherland, the British King Charles II gave the area that would become New Jersey to his brother James, Duke of York. James split the province between his two friends, granting control of East Jersey to Sir George Carteret, who died soon thereafter. Carteret's widow, Elizabeth, then sold the land at public auction to 12 Scottish "proprietors," who each took a partner, for the price of 3,400 pounds. This 1685 Map of Rariton by John Reid, the first deputy surveyor under the proprietors of East Jersey, shows some of the first divisions of land along the river, though most of these plots were purely speculative. (Courtesy of the Library of Congress Prints and Photographs Division.)

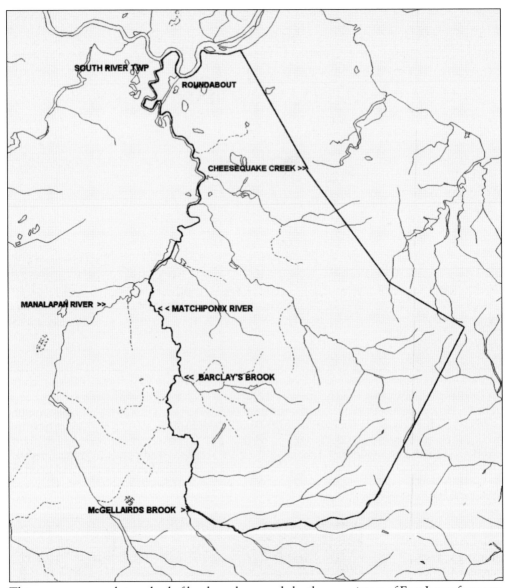

This map corresponds to a deed of land purchase made by the proprietors of East Jersey from two Lenape, identified as the sachems Neskorhock and Pamehelett, who sold the land outlined on this map for "one hundred & fifty fathoms of white wampam, fifty fathoms of black wampam, sixty match coats, sixty shirts, twenty yards of stoneware, four hundred knives, one hundred tobacco tongues, one hundred tobacco pipes, twenty pounds of tobacco, fifty yards of plates, twenty brass kettles, twenty guns, forty blankets, fifty pairs of stockings, fifty hatchets, fifty fine tobacco bowls, One hundred pounds of lead, eight and twenty pounds of beads, thirty glass bottles, thirty tin kettles, fifty pounds of gunpowder, twenty gallons of wine, two barrels of beer, and two barrels of cider." (Courtesy of the Sayreville Historical Society.)

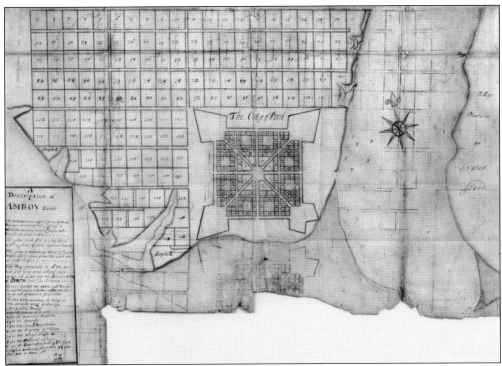

After the 24 proprietors were issued their patent to East Jersey on March 14, 1683, they chose for their capital a location the Lenape called Omoye and named it for James Drummond, Earl of Perth, Scotland. Anglicized by the Scottish settlers, the name "Perth Amboy" first appeared in 1692, and the port city became the center of proprietary influence, home of its leaders, and headquarters of the board of proprietors. The original plan for the city of Perth, at Amboy Point, was Boroque in design and included an impressive coastal defence and a grid design that predates New York's. Venture capitalists, the proprietors envisioned Perth Amboy as a second London, though its port was quickly overshadowed by those of New Brunswick and New York. (Courtesy of the New Jersey State Archives.)

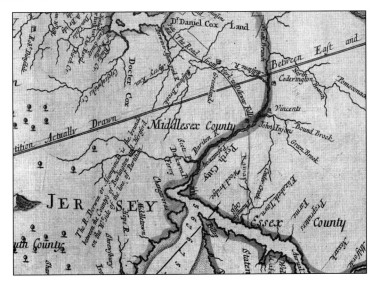

John Inian, credited with founding New Brunswick, first purchased 12 lots here along the Raritan, each a half mile long. He then built a tavern near what became the corner of Albany and Water Streets and provided ferry service across the river. He also improved the Lenape trails around which New Brunswick grew. (Courtesy of the Library of Congress, Prints and Photographs Division.)

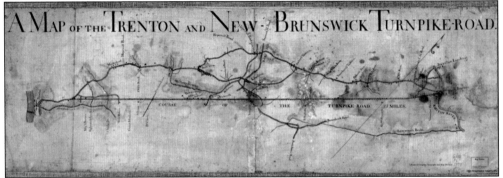

John Inian is credited with improving the road from his ferry crossing at the Raritan down to Trenton. From early on, the importance of this corridor between New York and Philadelphia was obvious, and the road was continually improved. The trip from New York to Philadelphia took three days in Colonial times, but with the introduction of the new English stagecoach in 1760, the journey was reduced to two days, with a stopover in Princeton. (Courtesy of the Library of Congress, Prints and Photographs Division.)

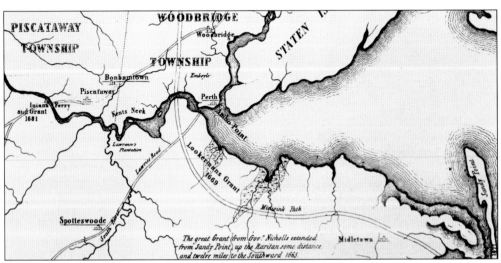

In response to Inian's Ferry, which increased traffic along the old Indian path that the Dutch called the "Upper Road," connecting the Noordt (Hudson) River at Elizabethtown with the Zuydt (Delaware) River, the proprietors at Perth Amboy opened a road to Burlington via the ferry to South Amboy, thus settling that town. (Courtesy of the Madison Township Historical Society.)

South Amboy was originally referred to as the "Outer Plantations" or "Detached Plantations" of Perth Amboy. When Andrew Radford began operating a ferry between the Amboys in 1684, South Amboy became a port city of some consequence in its own right, as a vital link to stagecoaches that took travelers to points south. Ferries connected the Amboys for almost 200 years before a railroad bridge was built in 1875. (Courtesy of the Madison Township Historical Society.)

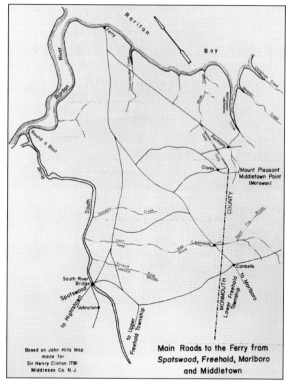

Based on John Hills Map
made for
Sir Henry Clinton 1781
Middlesex Co. N.J.

Main Roads to the Ferry from
Spotswood, Freehold, Marlboro
and Middletown

Lawrie's Road (known today as Bordentown Avenue), pictured here in the 1930s, connected South Amboy with Bordentown and grew in competition with the Upper and Lower Roads that took travelers through New Brunswick. By the 1750s, advertisements for both routes appeared in Colonial newspapers, hoping to profit from the constant flow of travelers between the old Dutch capital of New York and the largest city in the colonies, Philadelphia. In his autobiography, Benjamin Franklin describes making this trip in 1719, riding Radford's ferry to South Amboy, where he began a two-day journey on foot along Lawrie's Road. (Courtesy of the Sayreville Historical Society.)

In 1684, to accommodate Andrew Radford's ferry service between the Amboys, deputy governor Gawen Lawrie established a ferry slip at the foot of High Street in Perth Amboy, on the Raritan River. The following year, lawyer and member of the board of proprietors James Emott constructed Perth Amboy's first tavern here, the Long Ferry Tavern. Leading up to the American Revolution, the tavern, then in its heyday, was a popular place to eat, drink, and be merry—and discuss grievances against King George—while waiting to catch the ferry across the Raritan. Taverns were an important component of Colonial life, as men met and discussed the issues of the day there. This was especially true during the American Revolution. At that time, there was a grove of locust trees along the beach, popularly known as "Love Grove," which gave the tavern a generally attractive appearance and added to the pleasant scenery on the shore of the Raritan. The building was destroyed by fire in 1867. (Courtesy of John Kerry Dyke.)

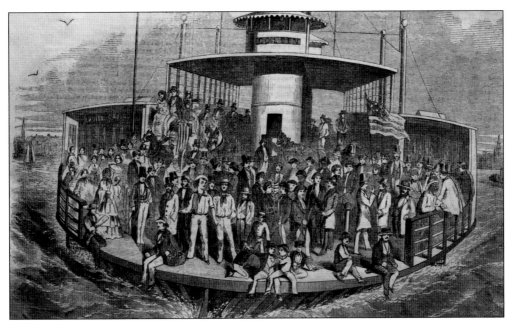

Also in 1684, ferry service was established between Perth Amboy and Staten Island. Prior to that, the Lenape had provided informal ferry service across the Arthur Kill. After Washington's crushing defeat at the Battle of Long Island, Adm. Richard Howe proposed a meeting to discuss terms for peace. The Continental Congress, then in session in Philadelphia, sent Edward Rutledge, John Adams, and Benjamin Franklin to Perth Amboy, where, on September 11, 1776, they rode the ferry back and forth to the home of Christopher Billop, located on the opposite shore, for the futile three-hour meeting. Ferry service continued here as a vital link between New York and Philadelphia, as depicted in the 19th-century illustration above. In 1928, the opening of the Outerbridge Crossing made the ferry obsolete, but service remained until the last ferry crossed on October 16, 1963. In 1978, the ferry slip (below) was added to both the New Jersey Register of Historic Places and the National Register of Historic Places. Located at the end of Smith Street, it was restored in 1998 to its 1904 appearance, and it currently serves as a maritime museum. (Both, courtesy of John Kerry Dyke.)

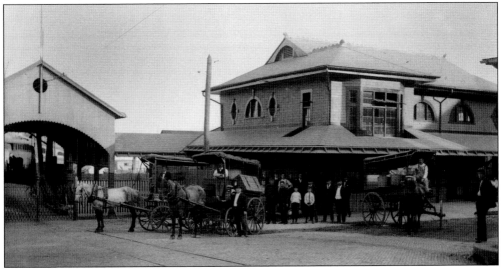

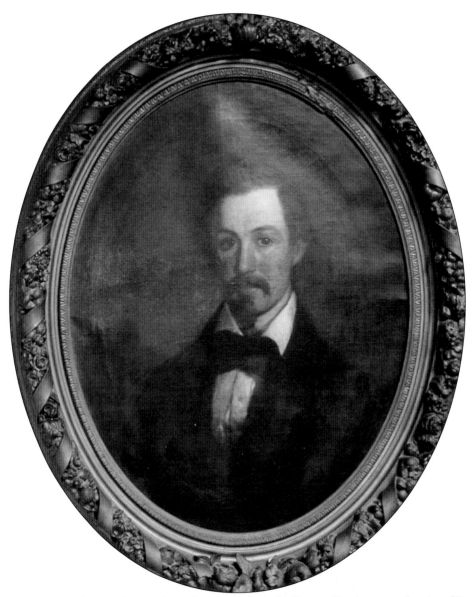

The Morgan family owned a sprawling plantation along the Raritan Bay between the city of South Amboy and Cheesequake Creek. Capt. James Morgan (1734–1784) and his son Maj. Gen. James Morgan (1757–1822) both served and were briefly taken prisoner in the American Revolution, during which time the British ransacked their mansion, breaking 23 windows, taking everything of value, and tossing their valuable kiln into Cheesequake Creek. The son, seen here, later served in the 12th US Congress and then in the War of 1812. In the 18th century, the Royal African Company established a major slave trading center at Perth Amboy, but when slavery was abolished in New Jersey, Major General Morgan, along with a number of other wealthy landowning families south of the Raritan, devised and executed a plan to secretly smuggle their slaves to the South for profit. In March 1818, by cover of night, the sloop *Thorpe* left Wilmurt's dock in South Amboy and transferred a number of slaves to the brig *Mary Ann*, which had been waiting in the bay to transport the human cargo to New Orleans. The clandestine operation was later exposed, but none of the men ever faced charges. (Courtesy of the Sayreville Historical Society.)

One morning in July 1776, over 150 British ships of war appeared on the horizon and filled Raritan Bay. The residents of the Amboys watched in awe as Adm. Richard Howe commanded a landing of over 9,000 troops on Staten Island. In response, Gov. William Livingston appointed Capt. James Morgan to guard the south side of the Raritan Bay and River with a militia of 50 men. (Courtesy of the Library of Congress, Prints and Photographs Division.)

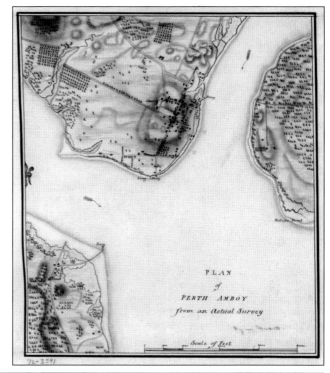

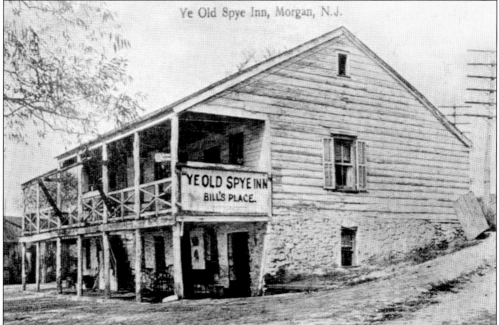

Nighttime raids on the British ships anchored in the bay were frequent, as locals in small boats launched from the many rivers, inlets, and creeks along the shore. The Ye Old Spye Inn on Cheesequake Creek was one place where raiders could seek refuge. Lost to a fire in the 1970s, the inn earned its name from a legend of a loyalist spy who was hanged there during those tumultuous years. (Courtesy of the Sayreville Historical Society.)

After mortally wounding Alexander Hamilton in their famous duel, Vice Pres. Aaron Burr landed on the beach at Perth Amboy and sought refuge with Commodore Thomas Truxton, who sympathized with Burr and thought the duel justified. Truxton accompanied Burr to Cranbury the following day. Situated high above the Raritan on the Perth Amboy bluff, the Truxton House was built in 1685 by Gov. Andrew Hamilton. It has since been torn down. (Courtesy of John Kerry Dyke.)

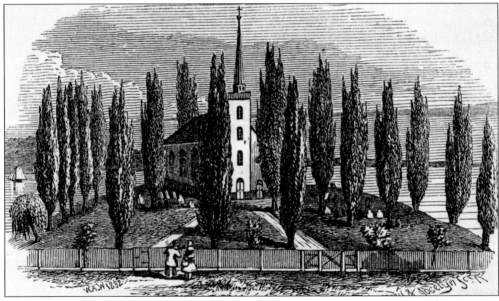

New Jersey's oldest Episcopal parish, St. Peter's Church, was organized in Perth Amboy in 1698. In July 1776, Colonists exchanged fire with a British ship anchored in the bay, causing damage to tombstones from musket fire. When the British took control of the city, they converted the church into a barracks, destroying much of the interior. The church has been rebuilt twice in its over-300-year history. (Courtesy of John Kerry Dyke.)

Perth Amboy is home to the only remaining royal governor's mansion in America. Commonly called the Proprietary House, it was constructed between 1762 and 1764 under the direction of the proprietors of East Jersey. In 1776, Royal Gov. William Franklin, a staunch loyalist and illegitimate son of Benjamin Franklin, was arrested here by a local militia. He was later released to British-occupied New York City in a prisoner exchange, and then went back to England in 1782. He never reconciled with his patriot father. In 1810, the house was reopened as Brighton, a luxury hotel boasting magnificent views of the Raritan Bay. The hotel failed, partly due to the economic unrest caused by the War of 1812, and then became a private residence, which it remained until 1883, when it became a boardinghouse under the name Westminster. For most of the 20th century, the house was neglected, but in recent decades, great efforts have been made to restore the Proprietary House for the great benefit and enjoyment of the public. (Courtesy of John Kerry Dyke.)

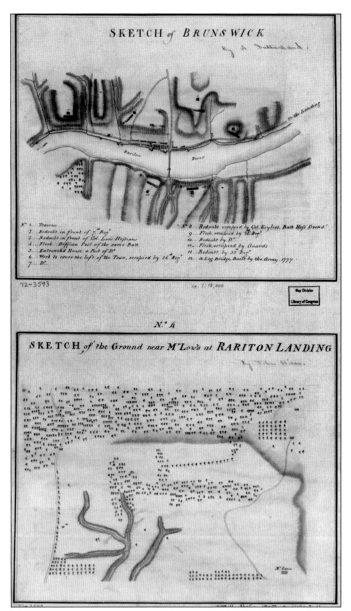

After passage of the Stamp Act, New Brunswick was a hotbed of activity for the Sons of Liberty, and Col. John Neilson gave one of the first public readings of the Declaration of Independence in Market Square in July 1776. After the British captured New York that fall, George Washington retreated across the Raritan with 4,000 troops, burning the Hamilton Street Bridge behind him in an attempt to impede the British army under Generals Howe and Cornwallis, who were in hot pursuit. New Brunswick remained under British occupation until June 1778, when, following the Battle of Monmouth, the Continental Army marched north and were granted a few days of much needed rest in the open fields of Raritan Landing, across the river from New Brunswick. There, the second anniversary of American independence was celebrated with a grand review. The troops lined the banks of the Raritan, their hats adorned with green sprigs, as General Washington rode past, followed by a 13-cannon salute over the river. (Courtesy of the Library of Congress, Prints and Photographs Division.)

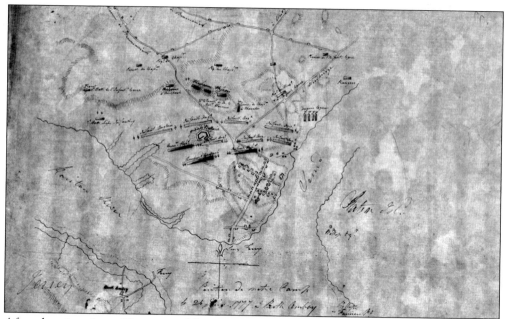

After the victories at Trenton and Princeton, Washington marched his army to the famous winter camp at Morristown. In response, the British took control of the Raritan, concentrating over 14,000 British, Hessian, and Anspach troops between Perth Amboy and New Brunswick. Classes at Queens College were suspended, and rebel leaders in New Brunswick fled with their families to the surrounding countryside, while many residents made an effort to show loyalty to the crown by selling produce to the occupying force. (Courtesy of the Library of Congress, Prints and Photographs Division.)

In 1789, New Jersey became the first state to ratify the Bill of Rights when it was signed at Perth Amboy City Hall, on a hilltop overlooking the Raritan River and Bay. Years later, in 1870, it was also at city hall that Thomas Mundy Peterson became the first black American to cast a vote under the newly ratified 15th Amendment. Built in 1717, it is the oldest city hall in continual use in the United States. (Courtesy of John Kerry Dyke.)

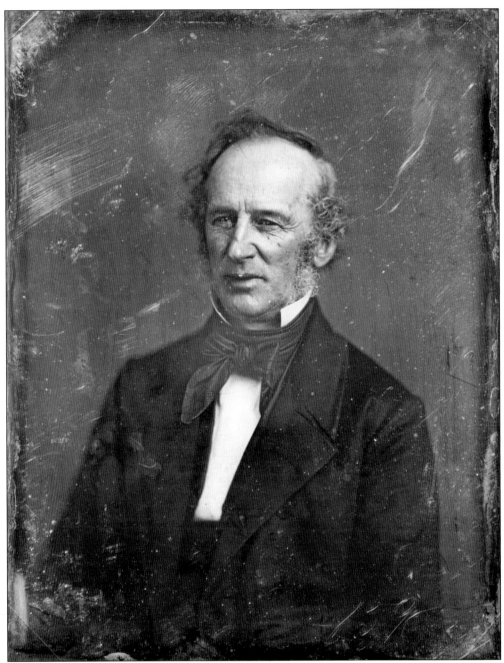

As a young man, Cornelius Vanderbilt made a name for himself as a merchant and boat captain in and around Staten Island and New York. After being hired by steamboat owner Thomas Gibbons, Vanderbilt took charge of the steamer *Bellona*, and eventually earned enough money to purchase a building in New Brunswick, which he turned into a hotel that he named for his steamboat, the *Bellona*. Vanderbilt was keenly aware of the profit to be made from the building's location, on the banks of the Raritan in New Brunswick, at the very head of steamboat navigation, as it was here that travelers transferred to either the steamboat to New York City or the stagecoach to Philadelphia. (Courtesy of the Library of Congress, Prints and Photographs Division.)

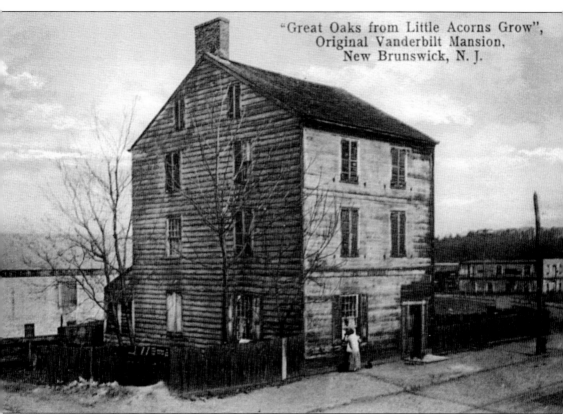

"Great Oaks from Little Acorns Grow",
Original Vanderbilt Mansion,
New Brunswick, N. J.

While Vanderbilt steamed up and down the river, his wife (and first cousin), Sophia, whom he married at 20, tended the hotel. Between 1815 and 1839, Sophia Vanderbilt gave birth to 13 children here. The children helped her run the hotel, and she used her earnings to support them. Built in 1803, the Bellona Hotel was not only a sometimes necessary accommodation for travelers between New York and Philadelphia, but also a popular retreat for New Yorkers seeking the fresh air of the country and a refuge from the city. Many traveled on Gibbons' steamers simply for the pleasure of the trip. As the hotel's fame spread, parties were regularly organized to visit the popular destination and to enjoy the sights and sounds of the steamboat ride through New York Harbor and up the Raritan to New Brunswick. (Courtesy of the New Brunswick Free Public Library.)

New-Brunswick & New-York Packet,

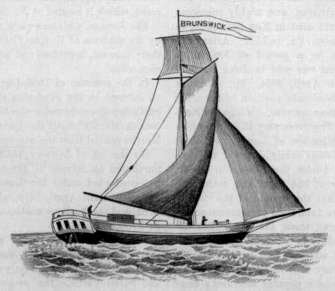

THE Subscribers inform the public, that they have commenced running, as a regular PACKET, between this City and New-York,

THE NEW SLOOP BRUNSWICK,

A. DEGRAW, MASTER.

She will sail, (wind and weather permitting) every Tuesday from Flagg and Degraw's wharf, New-Brunswick ; and every Friday from the White-Hall wharf, New-York. The most assiduous attention will be paid to all ORDERS for or with freight, and every convenience and comfort in the power of the Master will be afforded to passengers, the vessel having good accommodations.

J. C. Van Dyke,
Flagg & Degraw.

New-Brunswick, Sept. 1816.

N.B. Coarse and Fine Salt, Plaister of Paris, &c. (at New-York prices, adding freight) for sale ; and the highest price given for Corn and Produce generally, at Flagg & Degraw's Store, on the wharf next below the bridge.

Competition was fierce on the Raritan, with a great many vessels competing for passengers to and from New York. Advertisements such as this one for the *Brunswick* were an all-too common sight in New Brunswick. The coming of steamboats only intensified the competition. In 1824, the New Brunswick Steamboat Ferry Company launched the *Legislator*, charging only 12.5¢ for passage to New York, the lowest fare offered on the river. The *Bellona* and the *Thistle* were compelled to match the reduced fare, in what was the start of a decades-long price war. In the 1840s, when the luxury steamers *Raritan* and *Antelope* were in competition, both offering the same fare of 12.5¢, the *Antelope* attempted to edge out the competition by offering a free breakfast on board. A third steamer, the *New Philadelphia*, promptly responded by dropping its fare to 6.25¢. (Courtesy of the New Brunswick Free Public Library.)

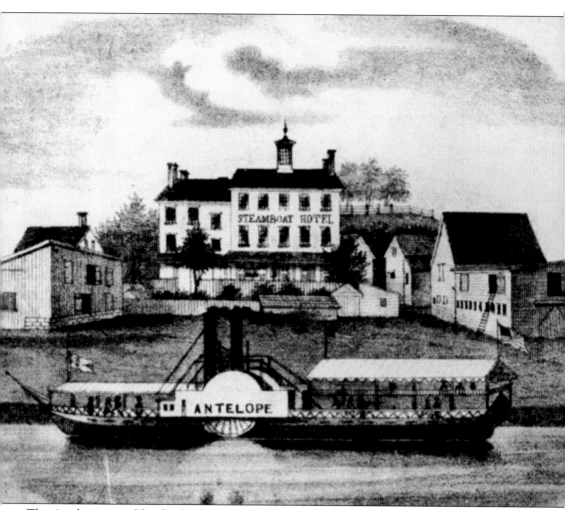

The *Antelope*, owned by the Perth Amboy Steamboat Company, was one of the most popular steamers on the Raritan. Capable of holding 600 passengers, it offered free excursions from New Brunswick, South River, Sayreville, Perth Amboy, and South Amboy to the beach at Keyport, and its interior showcased two large paintings of Washington crossing the Delaware. For many steamboat passengers, however, the accommodations inside the steamer were no less impressive than the scenery the trip offered. As one passenger traveling from New Brunswick wrote, "The Raritan finds its sinuous way through broad green salt meadows that stretch off like soft carpets until they meet the clay beds and tangled woods of the Jersey Shore. It was indeed Holland; the same flat landscape and long stretches of green marsh. One constantly expected a windmill to appear on the sedge, or the spires and crooked tiled roofs of a Dutch village." (Courtesy of the Sayreville Historical Society.)

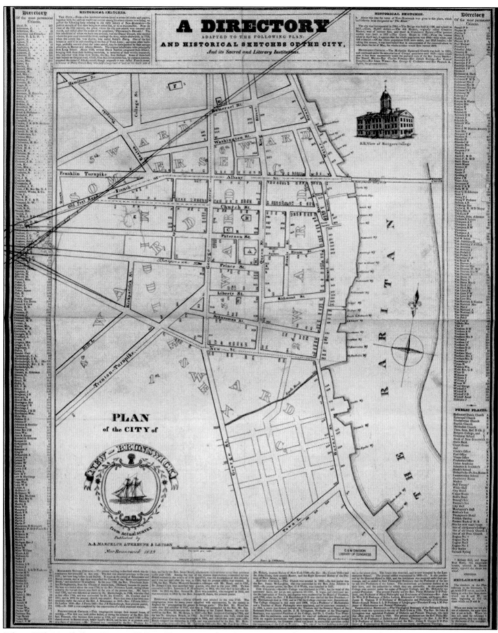

This "Plan of the City of New Brunswick" from 1829 shows a city on the brink of large-scale industrialization. With well-planned, straight roadways leading out to the countryside and a highly developed waterfront, this map shows New Brunswick as a busy center for the transport of grain and an important transportation link between New York and Philadelphia. This was a city poised for growth, home to just over 5,000 people. The inclusion of an illustration of Rutgers College indicates the importance of this institution to the small city and the pride it held in the imposing brick edifices of one of America's first colleges. This was a much quieter New Brunswick, before the Delaware and Raritan Canal, when a railroad was nothing more than a line on a map, an idea still waiting to be built. (Courtesy of the Library of Congress, Prints and Photographs Division.)

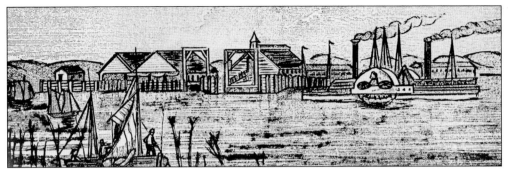

Appleton's Railroad and Steamboat Companion, published in 1847, aided travelers from New York City to Philadelphia via South Amboy, depicted here. Each morning at 7:00 a.m., for $3, passengers boarded a steamboat at the north river pier, near the Battery, bound for South Amboy. Once docked, passengers were transported from the steamboat to the railroad cars, which carried them through sand hills and "a barren and uninteresting region of country" before reaching the Delaware River at Bordentown. (Courtesy of the Madison Township Historical Society.)

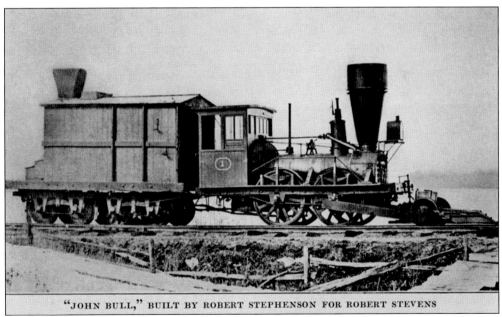

"JOHN BULL," BUILT BY ROBERT STEPHENSON FOR ROBERT STEVENS

New Jersey's first railroad, the Camden & Amboy (C&A) Railroad, was incorporated on February 4, 1830. Carriages were initially pulled by teams of horses, until the locomotive *John Bull* was imported from England. By the fall of 1833, the small locomotive was making regular trips between South Amboy and Bordentown. Shortening the travel time across the state and running parallel to Lawrie's Road, the C&A Railroad created a boom in steamboat traffic in South Amboy. (Courtesy of the Library of Congress, Prints and Photographs Division.)

This sketch of Perth Amboy showcases its prowess as a seaport. Prominently showing a steamboat in the foreground, the sketch was drawn at a time when this new technology was held in high esteem by all the ports at which the boats stopped. Sailing vessels still fill the bay, and the landing at the foot of High Street, the site of the Long Ferry Tavern, is at the center of the image. The steeple of St. Peter's Church rises from the bluff and would have been visible on the water from a great distance. (Courtesy of John Kerry Dyke.)

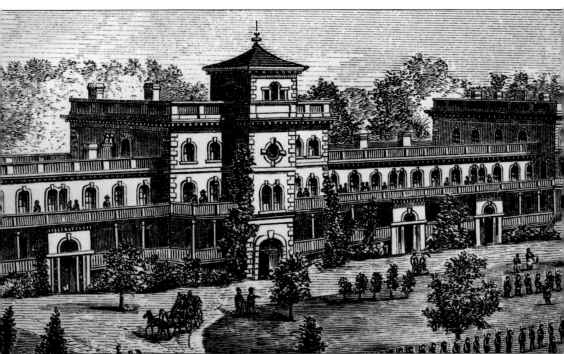

Perched high on a large plot of land overlooking the bay, Eagleswood Phalanx was the home of the Raritan Bay Union, a utopian community founded in 1853. Inspired by the French socialist Charles Fourier, members worked to correct social inequalities and used the phalanx as a women's rights headquarters and a boarding school that pioneered coeducation, encouraging girls to engage in sports and public speaking. Teachers here included the famous abolitionist sisters Angelina and Sarah Grimké. It was also an important stop on the Underground Railroad, where members used the Raritan River to transport slaves to and from their community on their journey north to freedom. Members ran a farm on the complex, attempting to save money and labor by working collectively. The Raritan Bay Union was also an active artists' colony, visited by such famous intellectuals as Henry David Thoreau, Theodore Weld, Peter Cooper, Horace Greeley, Ralph Waldo Emerson, George Inness, William Page, Louis Comfort Tiffany, and Susan B. Anthony. (Courtesy of John Kerry Dyke.)

Up the Raritan.

In this bucolic scene three miles north of New Brunswick, the Delaware and Raritan Canal flows gracefully through the landscape along the Raritan River, a symbol of modernity and a harbinger of the mass industrialization to come. Dug at the height of the "canal fever" that struck the nation after the success of the Erie Canal in New York, the Delaware and Raritan Canal enjoyed enormous success when it opened in 1834. For the first time, it allowed commercial vessels to travel up the Raritan beyond New Brunswick. Through 14 locks, ships carried goods to a height of 58 feet at Trenton before reaching the Delaware River at Bordentown, a total distance of 44 miles. The canal vastly expanded the economy of the lower Raritan River by opening it up to new markets and gave New Brunswick an arguable advantage over South Amboy, the terminus of the newly constructed Camden & Amboy Railroad. With the opening of the Delaware and Raritan Canal, the economic and industrial life of the lower Raritan was forever changed. (Courtesy of the New Brunswick Free Public Library.)

Two

GOD GIVEN WATERS

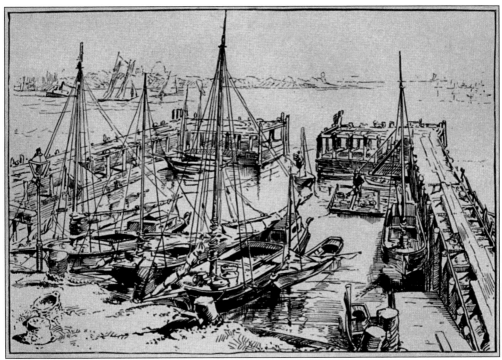

Oyster dredging was one of the first profitable industries along the Raritan. Great beds of oysters once covered the floor of the Raritan Bay, and the Lenape were known to travel to the Amboys for the Chingarora oyster, which was considered a delicacy. Oysters were so plentiful that the Great Beds Lighthouse was completed in 1880 to help steer ships away from the shallow beds. This 1887 illustration by Ernest Ingersoll shows oyster sloops docked at Perth Amboy, when the industry was in its heyday. (Courtesy of the National Oceanic and Atmospheric Administration, Historic Fisheries Collection.)

Peter Fisher (1818–1909) was born in Fishkill, New York, and became successful in the business of shipping aggregates. In 1850, he entered into a partnership with James R. Sayre of Newark, and the Sayre & Fisher Company began purchasing large tracts of clay-rich land along the south bank of the Raritan River, eventually buying out most of the small pottery and brick manufacturers then operating along the river. (Courtesy of the Sayreville Historical Society.)

The bend in the river where Sayre & Fisher built its main plant, known as "the Roundabout," was the prior location of James Wood's brickyard, a modest brick manufacturing operation that was absorbed by Sayre & Fisher. In Colonial times, the Price, French, and Letts families called the Roundabout their home, and all were engaged in the production of pottery, given the abundance of high-quality clay found here. (Courtesy of the Sayreville Historical Society.)

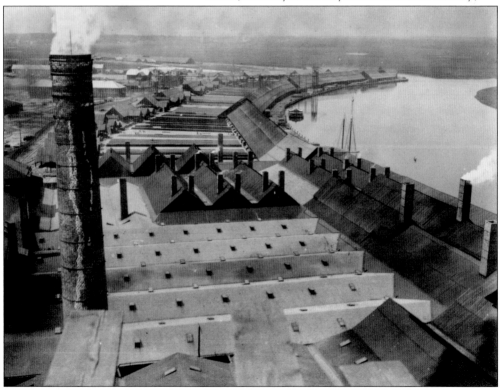

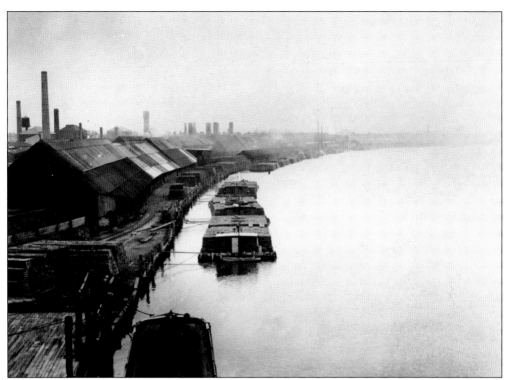

Before automobiles and railroad access, the Raritan River was the lifeblood of the Sayre & Fisher Company. The clay mined inland was transported to the plant by mules along a network of small-gauge railroad tracks, and the bricks that came out of the plant were loaded directly onto barges to be taken to the market. (Courtesy of the Sayreville Historical Society.)

The enormous clay deposits owned by Sayre & Fisher brought great wealth, and operations expanded rapidly. As production increased, so too did the workforce, comprised mainly of immigrants from Ireland, Germany, and Poland. The work was backbreaking, which is evident in this image of laborers wheeling stacks of bricks across gangplanks onto a barge. (Courtesy of the Sayreville Historical Society.)

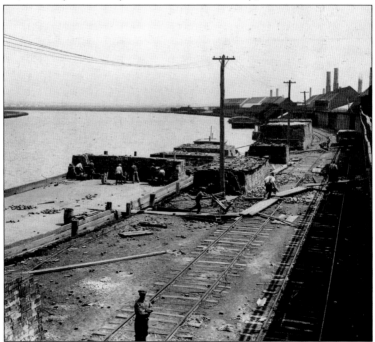

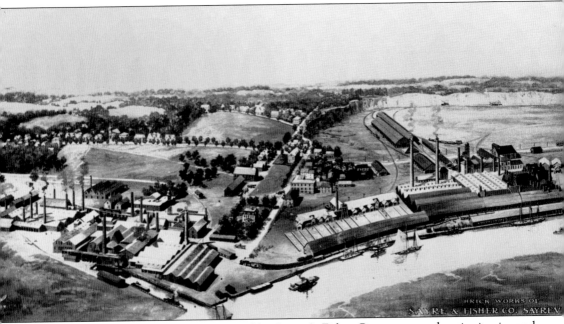

This illustration from around 1900, used by Sayre & Fisher Company to advertise its size and resources, provides a south-facing view of the plant. With increasing revenue came greater land acquisitions. The large pit behind the plant had previously been a hill of 80–100 feet, purchased over time for the abundant clay within. Possessing such large tracts of clay-rich land would have meant nothing, however, without access to the Raritan River. The Sayre & Fisher Company was

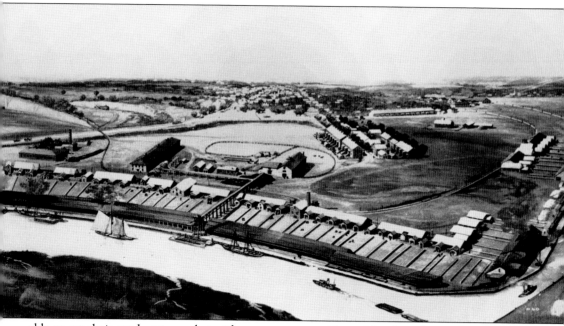

able to get their product to market with great ease, as evidenced by the volume of river traffic depicted here. The proximity of such vast clay deposits to the river allowed the Sayre & Fisher Company to grow into the world's largest brick manufacturer after only a few decades. (Courtesy of the Sayreville Historical Society.)

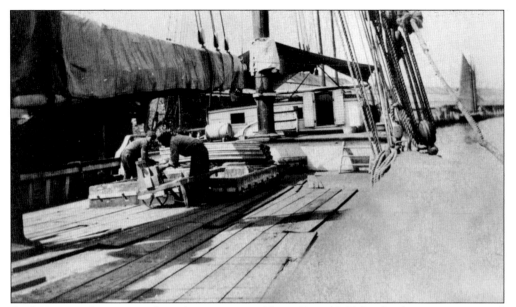

On barges or schooners, such as the one pictured here, Sayre & Fisher bricks were transported along the Raritan River to cities up and down the East Coast and used in the construction of many famous structures, such as the Brooklyn Bridge, the Empire State Building, the Breakers in Newport, and the base of the Statue of Liberty. (Courtesy of the Sayreville Historical Society.)

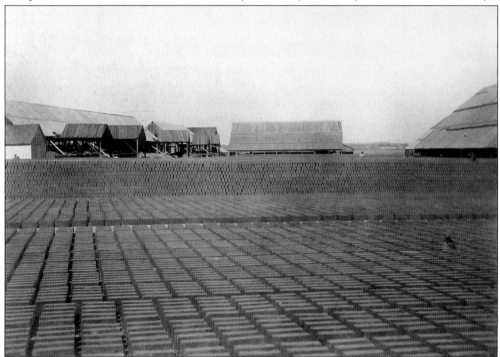

The mined clay, after being processed at the plant, was shaped in wooden molds and then laid out in the sun to dry before being fired in kilns. The company boasted that, by 1930, they had produced over five billion bricks, enough to build "a one foot wide pathway to the moon." (Courtesy of the Sayreville Historical Society.)

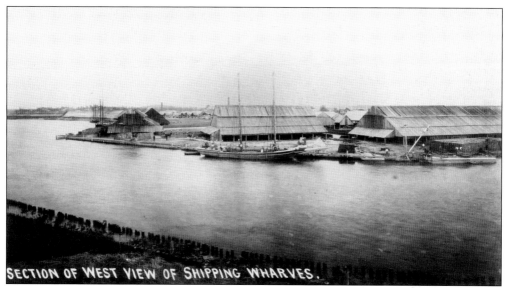

SECTION OF WEST VIEW OF SHIPPING WHARVES.

Over time, the Sayre & Fisher Company was able to acquire all of the land on the east side of the Washington Canal. Dug in 1831 to avoid the circuitous flow of the South River into the Raritan, the canal was originally intended to facilitate the transportation of produce to New York City, but it proved to be just as useful to the many brick companies along the South River. (Courtesy of the Sayreville Historical Society.)

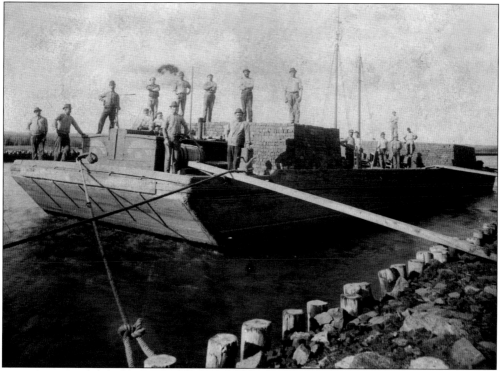

Every inch of waterfront property was valuable and put to use, as this picture illustrates. This barge docked along the canal appears to have just been loaded with bricks through the precarious use of gangplanks. (Courtesy of the Sayreville Historical Society.)

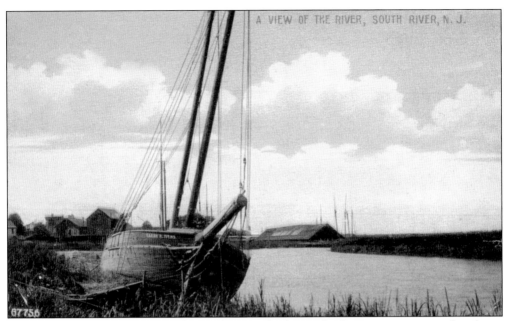

As this postcard shows, farther up the South River, the drone of industry gave way to an abundance of salt marshes. Behind the schooner to the left sits the town of Washington, which was originally settled around 1720. In 1898, it incorporated as the Borough of South River. To the right of the schooner, a brick shed rises from the banks of the river. (Courtesy of the South River Historical & Preservation Society.)

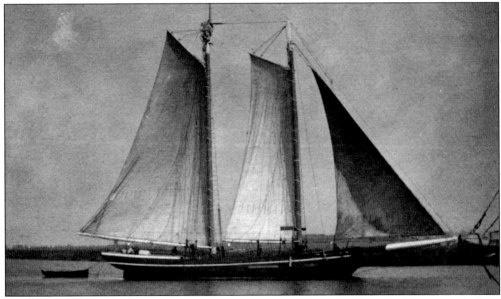

The town of Washington owed its growth to its river access, and it benefited enormously from the construction of the Washington Canal, which allowed greater river traffic and larger vessels, such as this schooner, to transport goods to and from its port. Initially, timber was the South River's main export, but, after the canal was completed, ships transported produce such as apples, pears, and peaches to New York City daily. (Courtesy of the South River Historical & Preservation Society.)

Looking north from the docks on the South River, the Washington Canal cuts a straight channel through salt marshes. (Courtesy of the South River Historical & Preservation Society.)

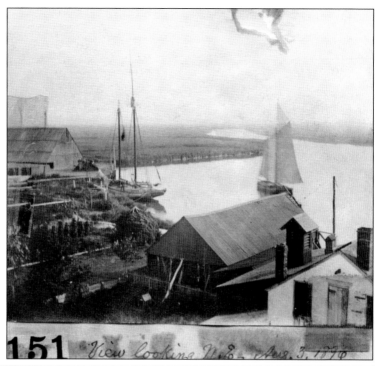

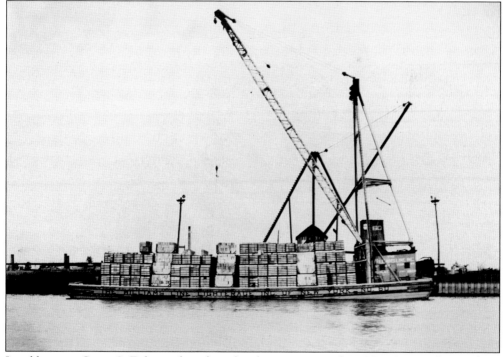

In addition to Sayre & Fisher, other clay-related companies such as New Jersey Clay Products made great use of the river. This photograph from the 1930s shows a barge being loaded along the east bank of the South River in Sayreville. Bound for New York City, this shipment was used in the construction of the Empire State Building. (Courtesy of A.J. Baumann.)

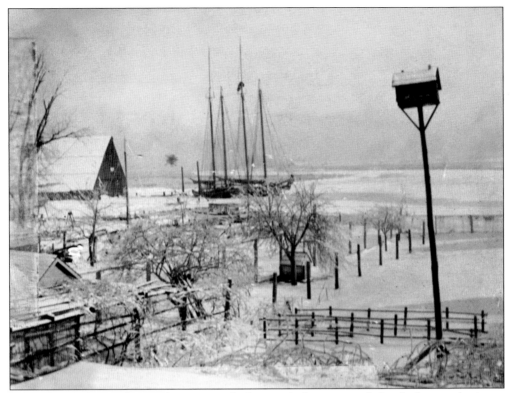

When the South River froze each winter, trade along its docks came to a halt, which was a detriment to the local economy. In the 1880s, in response to this annual problem, the town of Washington devised the "Mill Plan," whereby the town would attract and promote the construction of textile mills to supplement the local economy during the winter months. (Courtesy of the South River Historical & Preservation Society.)

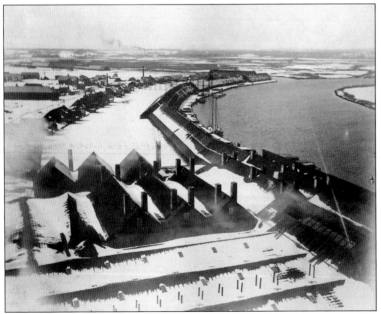

As this winter view of the Sayre & Fisher plant shows, while the Raritan might remain free-flowing during the winter, the ground would certainly be too frozen to mine clay. This slowed production at the plant and put many men out of work until the ground thawed again in the spring. (Courtesy of the Sayreville Historical Society.)

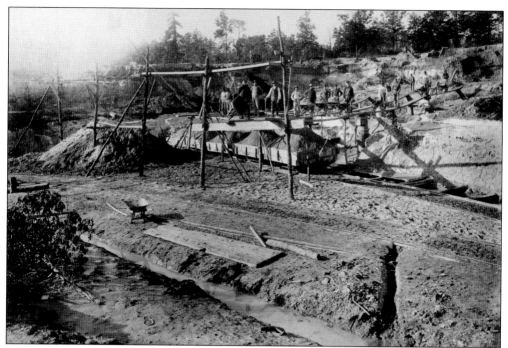

To the east of the Roundabout, the Crossman Sand & Clay Company began mining in 1903. Unlike Sayre & Fisher, Crossman's property extended over one mile inland. Crossman did not produce bricks, instead selling sand, a major component of asphalt, much of which went into the paving of New York City. The highly valued clay that ringed the sand here was sold by the bag, one of which was equal in value to a ton of Sayre & Fisher clay. (Courtesy of the Sayreville Historical Society.)

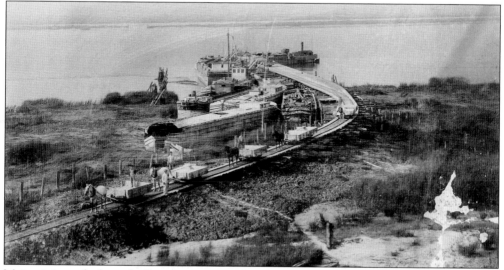

Maintaining a dock on the Raritan was crucial to the Crossman Company's operations. The size of their property required the use of horses, mules, and small locomotives, which hauled sand great distances to the river, where it could then be taken by barge to New York City or other destinations. Crossman maintained a stable for their many horses, such as those seen here pulling emptied carts back from the dock. (Courtesy of the Sayreville Historical Society.)

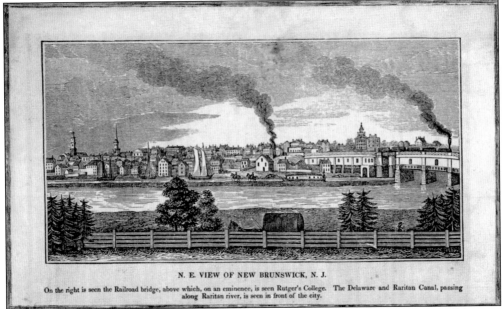

N. E. VIEW OF NEW BRUNSWICK, N. J.

On the right is seen the Railroad bridge, above which, on an eminence, is seen Rutger's College. The Delaware and Raritan Canal, passing along Raritan river, is seen in front of the city.

In New Brunswick, the Industrial Revolution changed the landscape and character of the city, where church steeples and the once imposing halls of Rutgers College were quickly outnumbered by smokestacks. Tench Coxe, assistant secretary of the treasury, saw this rapid growth and argued that moving the state capital to New Brunswick would enable New Jersey to grow as an industrial state, stating that "if any river in your state can be improved to accommodate the heart of it with internal water carriage, it must be the Raritan." (Courtesy of Rutgers University Special Collections.)

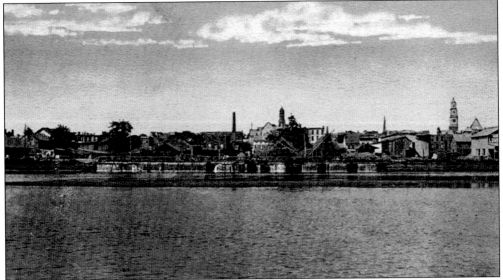

Spillover from the Delaware and Raritan Canal can be seen in this view of New Brunswick from the river. The canal, opened in 1834, greatly promoted the city's industrial growth by giving it a direct link with Trenton and Philadelphia. New industries began appearing in New Brunswick, including tanneries, a paint works, a glove factory, a dying plant, a pottery, and a brewery, in addition to numerous cabinetmakers, tailors, and other artisans. (Courtesy of the New Brunswick Free Public Library.)

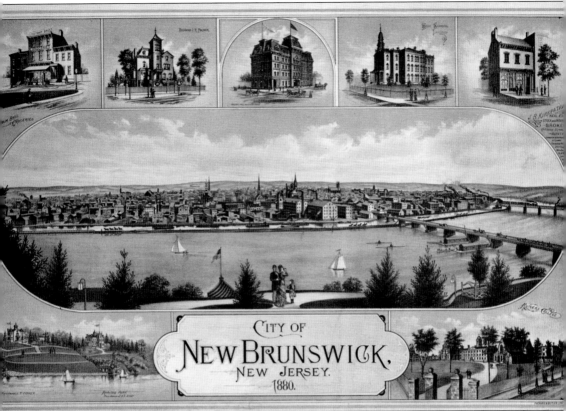

By 1880, New Brunswick had grown to a city of over 17,000 people. With a factory situated on the waterfront, Janeway & Company, manufacturers of wallpaper, became one of the city's leading companies. With nine printing presses, the factory produced millions of rolls of wallpaper each year, continually importing new designs from Paris. Also along the banks of the Raritan were the Norfolk New Brunswick Hosiery Company and the New Brunswick Rubber Company, two of the city's largest companies. Immigrants, primarily from Hungary and Poland, provided the workforce, and manufacturing supported the city's economy. This aerial view of New Brunswick shows a bustling industrial center, complete with smokestacks, railroads, a canal, and, most importantly, the Raritan River. These were the sources of the city's wealth, which resulted in the grand private residences and public buildings featured in the border of the illustration. (Courtesy of the Library of Congress, Prints and Photographs Division.)

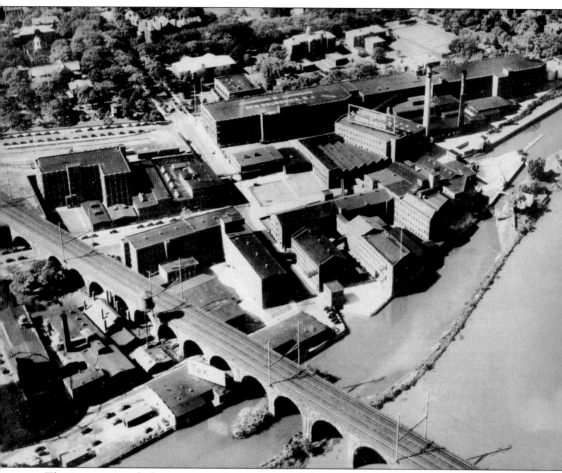

The international pharmaceutical corporation Johnson & Johnson established a factory in New Brunswick in 1887. Pictured here in 1938, the plant rapidly grew to be one of the largest industries in New Brunswick and on the lower Raritan River. It also led to an influx of Hungarian immigrants, who were attracted to New Brunswick because of the employment they found at Johnson & Johnson. By 1910, with a total population of 23,388, New Brunswick was home to 5,572 Hungarians. (Courtesy of the Sayreville Historical Society.)

This 1886 Sanborn Fire Insurance Map shows New Brunswick's waterfront just one year before Johnson & Johnson located next to the Norfolk New Brunswick Hosiery Company's plant. By 1886, the once quiet streets along the riverbank had been overtaken by a sprawling, loud, and dirty network of industries. (Courtesy of the Sayreville Historical Society.)

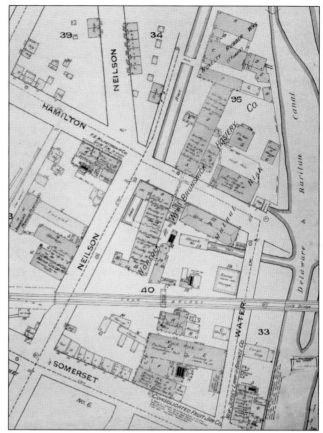

Taken from the towpath separating the river and the canal, this photograph shows the tugboat *James W. Johnson* docked in the Delaware and Raritan Canal at the Johnson & Johnson plant. The *James W. Johnson* was one of the boats in the Middlesex Transportation Company's fleet, which was owned by Johnson & Johnson, ensuring the company reliable access to river and canal transportation. (Courtesy of the New Brunswick Free Public Library.)

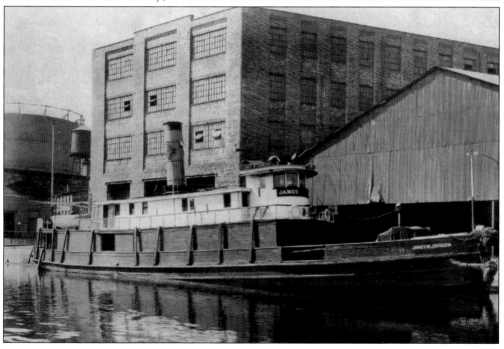

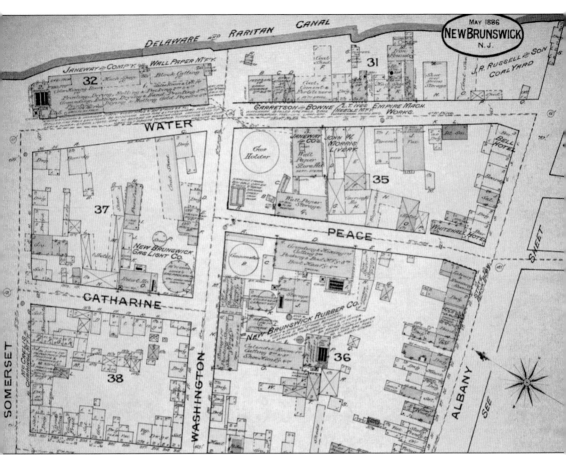

In the small stretch of riverfront property between the Albany Street Bridge and the Pennsylvania Railroad bridge, adjacent to the canal, industry flourished. The Janeway Company manufactured wallpaper alongside the Garretson & Bowne Empire Machine Works, which manufactured needles. Hotels operated beside coal yards. The New Brunswick Rubber Company, the New Brunswick Gas Light Company, and McCrelis Carriage Manufacturing all operated among a jumbled mix of butchers, grocers, drugstores, boardinghouses, and private residences. In 1886, manufacturing was in full swing in New Brunswick, as it enjoyed the benefits of the railroad, canal, and river, which made the city's location between the markets of New York City and Philadelphia all the more profitable.

New Brunswick enjoyed a wide variety of manufacturing. This view of the Home Valley Preserving Company, which advertised "Packers of Canned Foods" in painted letters on their building, was taken from the Albany Street Bridge. The original wooden railroad bridge is visible in the background, along with other industries filling in the waterfront. (Courtesy of the New Brunswick Free Public Library.)

This 1913 view of the waterfront shows both recreational boats in the river and industrial vessels in the canal. On land, church steeples rose up from the residential parts of the city, as smokestacks rose from the industrial waterfront. For those who lived here, the Raritan was a source of both work and recreation. (Courtesy of the New Brunswick Free Public Library.)

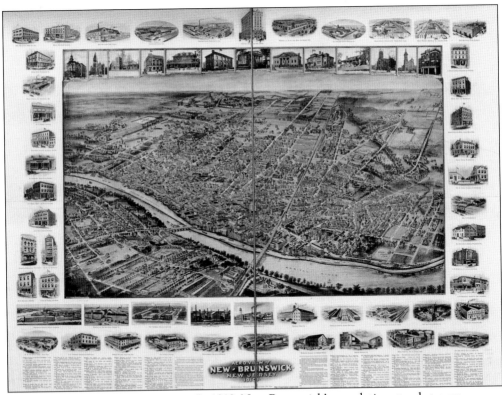

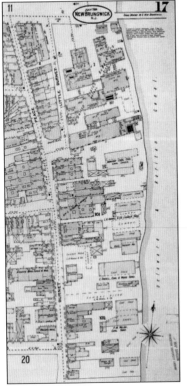

In 1910, New Brunswick's population stood at over 23,000, steadily rising since the beginnings of the Industrial Revolution. This aerial map of the city features illustrations of public institutions as well as a great number of industries, manufacturing lumber, granite and marble, shoes, string, furniture, iron, refrigerators, chemicals, and more. In the bucolic outskirts of the city, it appears that there is ample room for growth. (Courtesy of the Library of Congress, Prints and Photographs Division.)

In the area east of the Albany Street Bridge, near the entrance to the Delaware and Raritan Canal, the waterfront was filled with coal sheds. Coal was a coveted natural resource, necessary for powering New Brunswick's industries. The canal greatly facilitated the importation of coal from the anthracite fields of eastern Pennsylvania. (Courtesy of the Library of Congress, Prints and Photographs Division.)

Out at the other end of the lower Raritan, where the river met the bay, the Pennsylvania Railroad was hauling coal in staggering quantities to the docks of South Amboy. This 1876 map of the small city is dominated by railroads, with dozens of spurs leading out to the docks. Here, coal from Pennsylvania was loaded onto barges bound for the ports of larger cities, which relied on this steady supply for energy. (Courtesy of the Sayreville Historical Society.)

With the coming of the Camden & Amboy Railroad in the 1830s, South Amboy grew into a railroad town. Railroads carried passengers across the Raritan into South Amboy and then on to the Jersey shore, as freight was brought in to the city docks. The city's economy was inextricably tied to railroads and the docks that they used to transport coal and aggregates such as sand. On May 9, 1950, an explosion rocked the city when 450 tons of military munitions detonated on pier 4 while waiting to be loaded onto a barge. A total of 31 people died in the explosion, and only 5 bodies were ever identified. (Author's collection.)

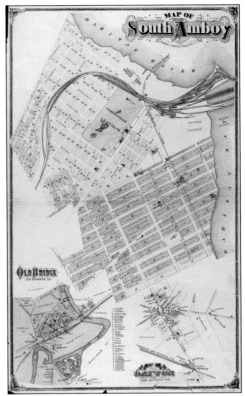

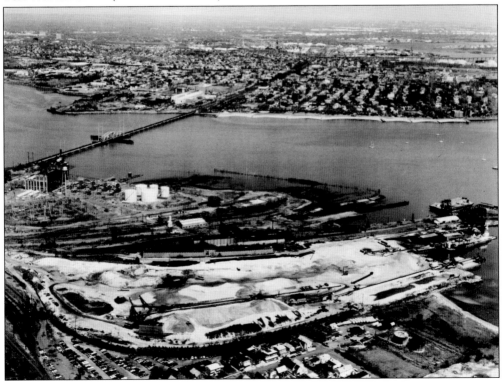

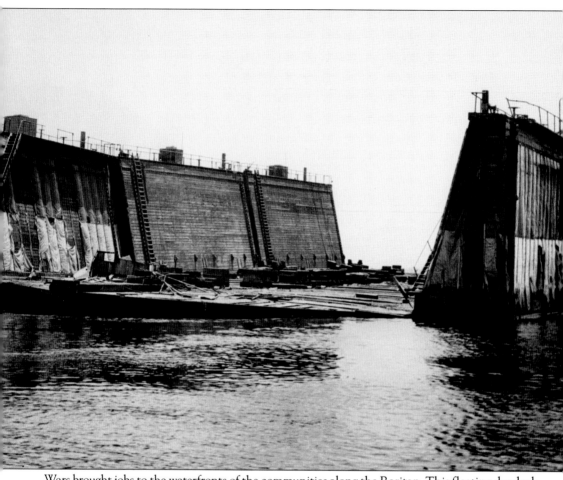

Wars brought jobs to the waterfronts of the communities along the Raritan. This floating dry dock at South Amboy, built during World War II, was abandoned after the war. It quickly deteriorated, as this 1966 photograph shows, but remained at the waterfront, where numerous times it broke away from the shore and floated into the channel, causing a navigational hazard. It has since been removed. (Author's collection.)

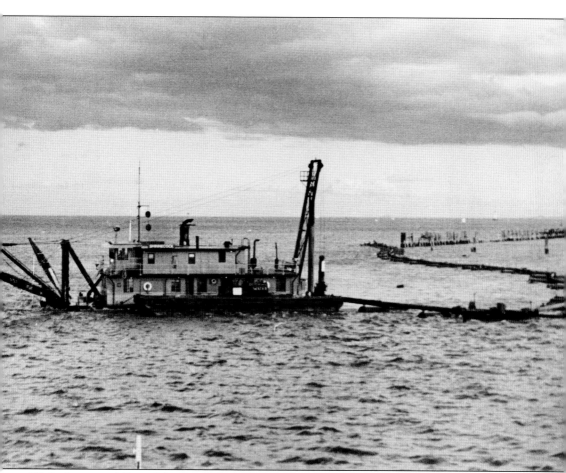

With the natural flow of the Raritan River to the sea came a great deal of silt, which continually decreased the depth of the water at the Amboys. As South Amboy's economy depended on its port, dredging was a necessary part of its operation. The dredge *Shinnecook*, pictured here, was one of many that kept the shipping channel at a depth capable of handling the vessels coming into port. (Author's collection.)

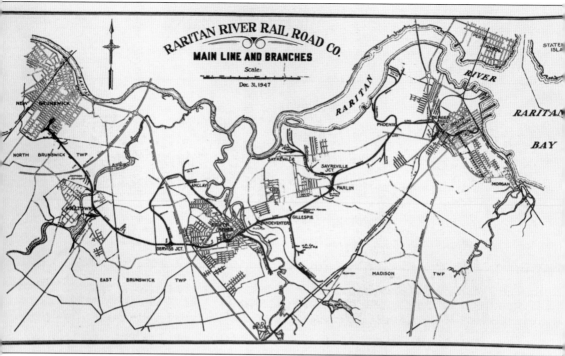

In the 19th century, the south shore of the Raritan River grew to become one of the most industrialized regions of the state. The industries here grew because of the transportation the river afforded them, but only New Brunswick and South Amboy had access to railroads, a cheaper mode of transportation. In 1888, construction began on the Raritan River Railroad, which linked all of the communities along the Raritan with each other and with the larger railroads in its anchor cities. Though it initially offered passenger service, this was abandoned after just a few decades, and the railroad became strictly industrial, not only supporting the existing industries along its path, but also instigating the construction of many new ones. One notable example of this is Dupont, which chose to build a plant away from the river but adjacent to the railroad, in an area they would call Parlin. The Raritan River Railroad was one of the most profitable railroads in the nation, growing in direct competition with the river for which it was named. (Courtesy of the Sayreville Historical Society.)

Because of the Raritan River Railroad, industries became less reliant upon the river. Oscar Bohi's embroidery factory was one such company. Although the factory was located on the banks of the South River, the Raritan River Railroad, which crossed here, offered an easier way to get Bohi's products, which included clothing, embroidery, and lace, to market. (Courtesy of Donna Kornacki Green.)

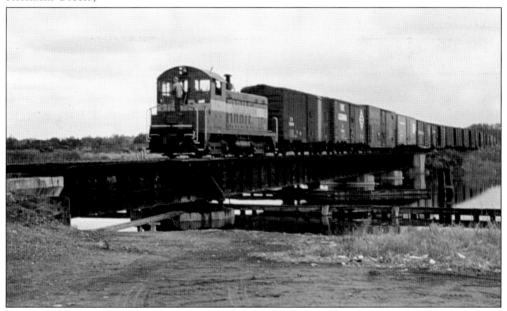

This later image of the same bridge over the South River, a swing bridge, captures a Raritan River Railroad engine pulling boxcars between Sayreville and South River. The railroad declined with the proliferation of trucking, and in 1980, it was absorbed by Conrail. The tracks are still operated by Conrail, though most of the sidings, which connected factories to the main line, have since been removed or abandoned. (Courtesy of A.J. Baumann.)

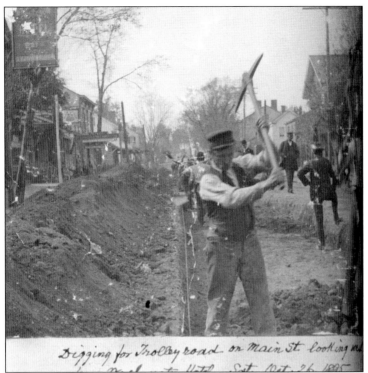

Digging for Trolley road on Main St looking n... ...Sat Oct 26 1895

Beginning in the 1890s, the trolley offered an alternative to the Raritan River Railroad for quick transportation between New Brunswick and South Amboy. This photograph shows workers digging along South River's Main Street so that the tracks could be laid. After falling out of use, and with scrap metal in high demand, most of the tracks were removed during World War II to support the war effort. (Courtesy of the South River Historical & Preservation Society.)

One of the benefits of the trolley was its ability to give residents greater access to employment. For the first time, many people now had the opportunity to work for industries farther from their homes. In this photograph, a trolley motorman poses in the Crossman Company's clay pits, where the trolley tracks cross the small-gauge tracks leading to the river. (Courtesy of the Sayreville Historical Society.)

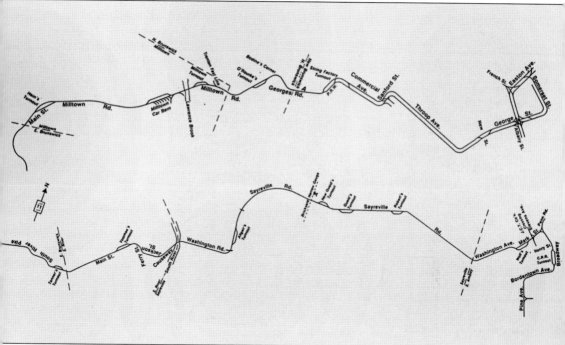

The trolley also connected area residents to leisure activities, such as shopping in the business districts of New Brunswick and South Amboy, which before would have been nearly impossible for many people in other towns. Many residents in places such as Milltown, Sayreville, and South River were first- or second-generation immigrants, and the opportunity to shop or see a movie, one of the new forms of leisure at the time, was a great thrill, one that also helped assimilate them, and everyone else, into the growing American consumer culture. This map shows all of the streets, many of which were business districts, through which the trolley traveled between New Brunswick (top right) and South Amboy (bottom right). (Courtesy of the Sayreville Historical Society.)

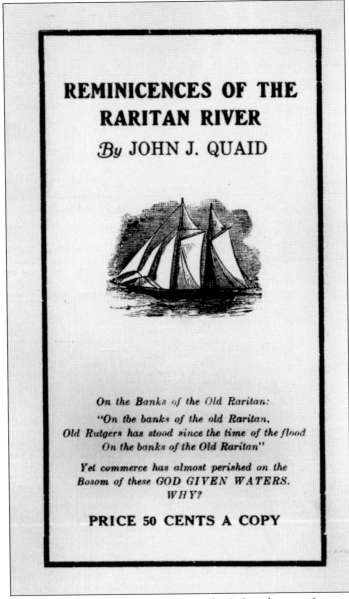

REMINICENCES OF THE RARITAN RIVER

By JOHN J. QUAID

On the Banks of the Old Raritan:

"On the banks of the old Raritan,
Old Rutgers has stood since the time of the flood
On the banks of the Old Raritan"

Yet commerce has almost perished on the
Bosom of these GOD GIVEN WATERS.
WHY?

PRICE 50 CENTS A COPY

This pamphlet, distributed by Sayreville's first mayor, John J. Quaid, argues for a return to the river. Quaid believed that the Raritan River was essential to the growth of the region, and argued that the river had been taken away from the people by three corporations: the Pennsylvania Railroad, the Sayre & Fisher Company, and Johnson & Johnson. The purpose of the pamphlet was to convince both the public and legislators of the need to dredge the south channel of the Raritan, which had become unusable because of dredge deposits made there by the three aforementioned industries, in conjunction with the Raritan River Railroad, in order to eliminate competition with other industries. Quaid listed a number of industries that were forced out of business because of the dredge deposits, including the Middlesex Brick Company, the Smith Brick Company, and the New Brunswick Steamboat Company. Many docks were also forced to be abandoned, including the Whitehead Brothers Company dock, the Such Clay Company dock, and nearly every dock on Kearny's Point. (Courtesy of the Sayreville Historical Society.)

Regardless of the troubles with the south channel, the Raritan River was continually used as a selling point for industry. Sayreville, particularly, went to great lengths to attract industries, and, as this advertisement shows, the Raritan River figured prominently in the borough's vision of a fully industrial community. Industry brought Sayreville into existence, and the jobs and tax revenues it provided were things the borough was not willing to lose. (Courtesy of the Sayreville Historical Society.)

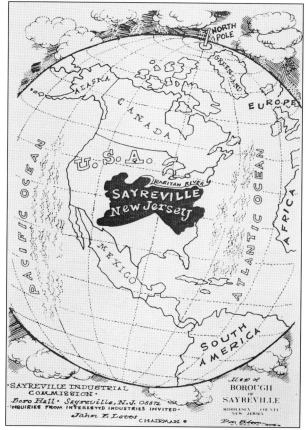

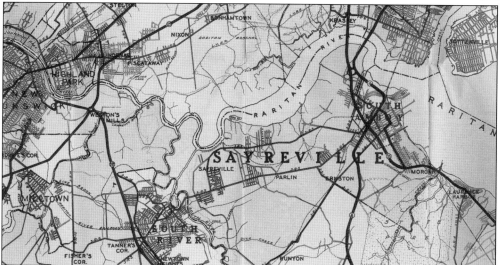

By 1947, very few people who lived in the towns along the Raritan River actually saw the river regularly. As this road map shows, most neighborhoods were built inland, and the absence of roadways near the river was not because it was not developed, but because industries were located there. Even in New Brunswick and South Amboy, which were built out from the water, industry had consumed their waterfronts. (Courtesy of the Sayreville Historical Society.)

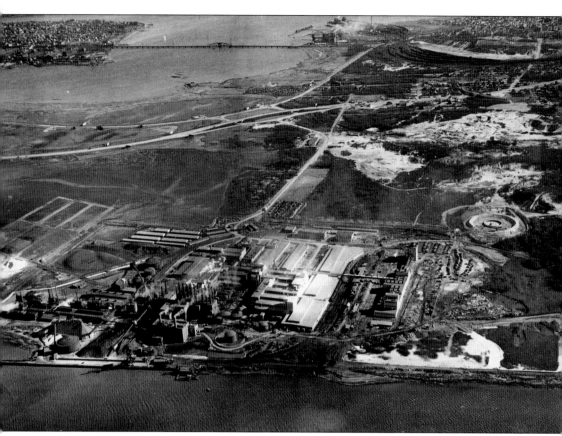

After having mined all of the land along the river for clay, in 1934, the Sayre & Fisher Land Company, the real estate division of the brick company, sold property at Kearney's Point to National Lead, which built one of the largest plants on the river, where they produced pigment used in paint. Later, the company began manufacturing a product called Titanox, which was used in paints, enamels, lacquers, paper, and rubber. (Courtesy of the Sayreville Historical Society.)

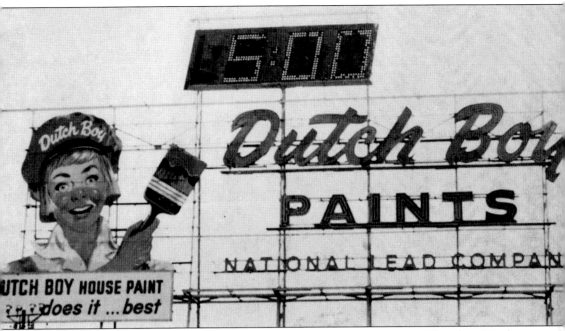

Dutch Boy paint was one of National Lead's most well-known products. For decades after the company located in Sayreville, this billboard greeted motorists on the highways that crossed the Raritan. (Courtesy of the Sayreville Historical Society.)

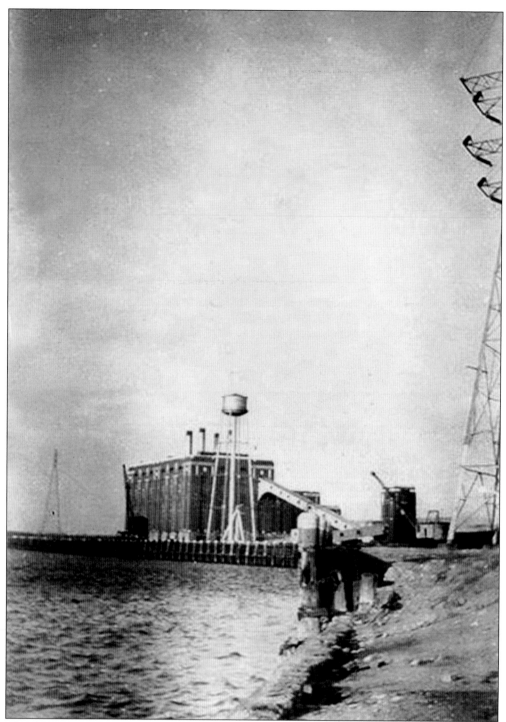

Thanks to the great availability of coal on the Raritan River, the Sayre & Fisher Company built a powerhouse around 1900 that was used to run their plant. In 1903, the company generously extended their electricity to the community, powering the first streetlights along Sayreville's Main Street. (Courtesy of the Sayreville Historical Society.)

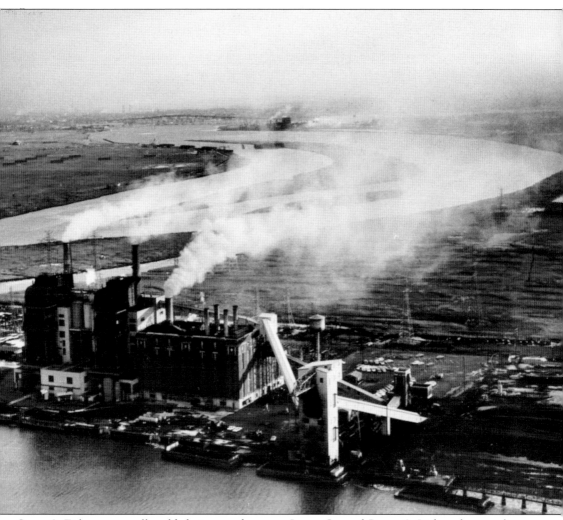

Sayre & Fisher eventually sold their powerhouse to Jersey Central Power & Light, who greatly expanded the plant to meet the growing energy needs of the surrounding area. The original brick structure is still visible in the center of the plant, and the sweeping east-facing view of the Raritan behind the powerhouse shows very clearly the divide between the north and south channels of the river. (Author's collection.)

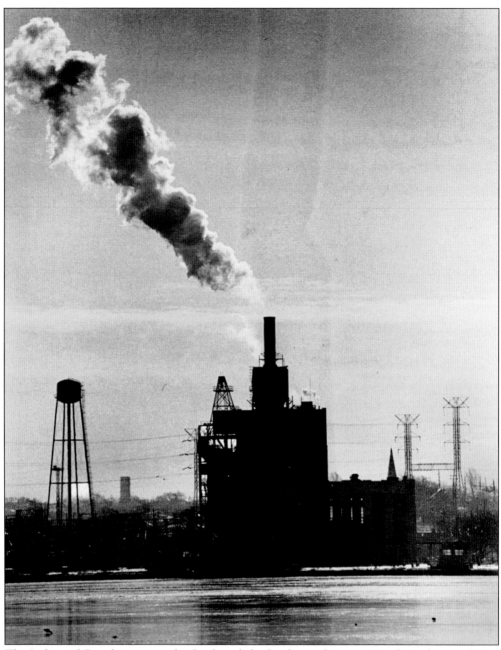

The Industrial Revolution completely altered the landscape between South Amboy and New Brunswick. The river that had once been a source of food for the Lenape who inhabited this region had become a source of industrial might for its new residents. Forests and marshlands all along the river were replaced by factories and rail yards, as the Raritan was eventually completely removed from the lives of the people who lived along its shores. (Author's collection.)

Three

ACROSS THE RARITAN

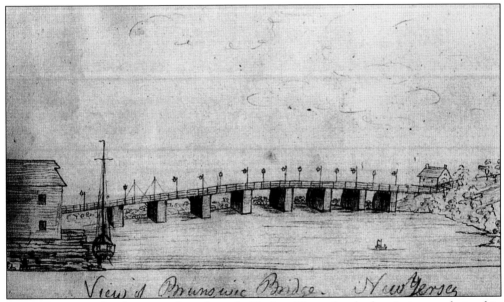

View of Brunswick Bridge. New Jersey

When Europeans first began settling along the Raritan River, they had an intimate relationship with the water. The movement of goods, raw materials, and people along the river was a part of life for nearly everyone who lived here, and it was the only way to travel in Middlesex County. But with the coming of established roadways, sometimes it became necessary to quickly get over the Raritan. Although other inconsequential wooden bridges existed, this illustration from the 1790s shows the first permanent Albany Street Bridge in New Brunswick. (Courtesy of the New Brunswick Free Public Library.)

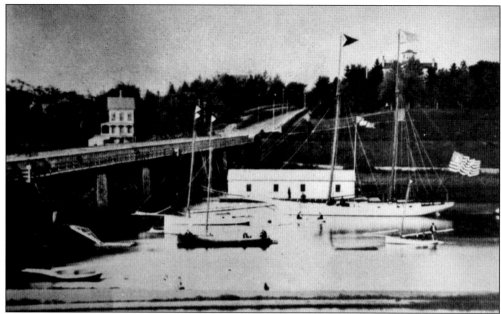

The first Albany Street Bridge was torn down and rebuilt in 1844, and the new bridge was constructed with the same low clearance. At the head of sloop navigation, the river was too shallow at this point for large vessels to continue up the river, so a higher clearance or a drawbridge was unnecessary. As a result, small recreational boats made great use of this part of the river. (Courtesy of the New Brunswick Free Public Library.)

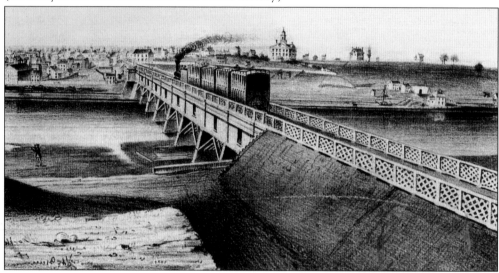

After the Camden & Amboy Railroad had shown its viability as a link between New York and Philadelphia, the New Jersey Railroad responded with a more ambitious rail line across the state by linking Highland Park with Jersey City, which brought their rails closer to New York. Anxious not to lose out on profits, the Camden & Amboy Railroad extended their rails up from Bordentown to Trenton and then on to New Brunswick. For three years, passengers had to disembark at the Raritan and cross on foot or by stagecoach until a double-deck bridge was completed in 1838, with the lower deck for horses, carriages, and pedestrians. In this illustration, Queen's College sits peacefully on a hill high above the river. (Courtesy of the New Brunswick Free Public Library.)

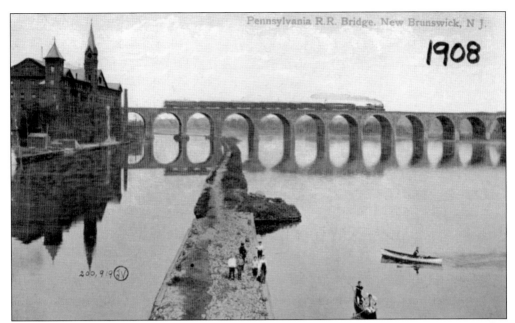

In 1878, the railroad bridge burned, and, in three days, a temporary steel bridge was constructed to keep trains moving. The temporary bridge lasted until it was replaced in 1903 by the stone arched bridge seen in this postcard. Still in use today, the bridge cost over $2 million, and 12 men were killed during its construction. On the left is the Delaware and Raritan Canal, with its towpath running down the center of the postcard. (Courtesy of the New Brunswick Free Public Library.)

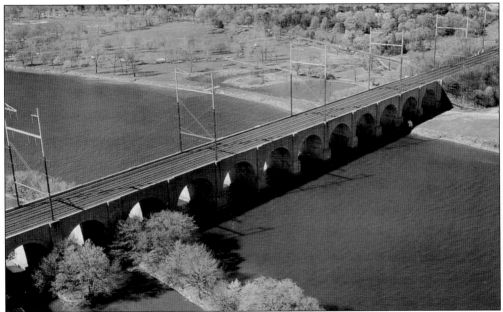

After decades of neglect, the natural succession of vegetation overtook the canal's towpath. And as traffic on the canal ceased, rail traffic increased. In 1932, the rails were electrified, and in 2000, the high-speed Acela began service over the Raritan with an average speed of 125 miles per hour, a far cry from the days of Inian's ferry. Today, this is the busiest rail route in the nation in both ridership and frequency. (Courtesy of the Library of Congress, Prints and Photographs Division.)

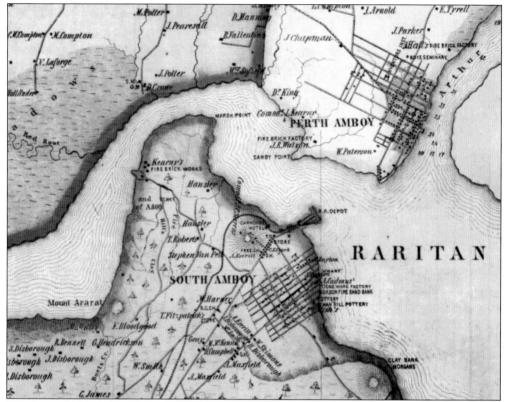

While trains carried passengers effortlessly across the Raritan in New Brunswick in 1850, in the Amboys, ferries were still the only way across the river. As this map shows, the population centers were densely nestled closely to the water, which remained the most common way in or out of the cities. But with Perth Amboy's population at 1,865 and South Amboy's even higher at 2,266, and a sparsely populated countryside all around, the two population centers needed a better connection. (Courtesy of the Sayreville Historical Society.)

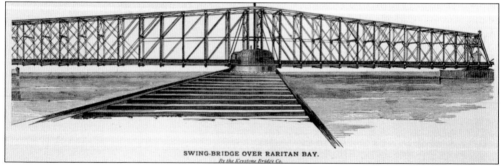

SWING-BRIDGE OVER RARITAN BAY.

In 1875, the New York & Long Branch Railroad Company took on the challenge of connecting the Amboys with a railroad bridge. They contracted the Keystone Bridge Company of Philadelphia to undertake the construction of the 472-foot-long wrought-iron bridge, which, until 1888, was the longest pivot-span ever built. The new bridge not only connected the Amboys, but it also connected New York City to the Jersey shore for the first time, helping shore towns grow. (Courtesy of Rutgers University Special Collections.)

66

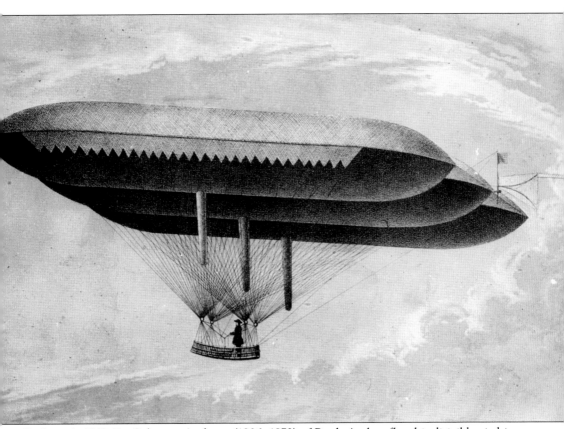

On June 1, 1863, Dr. Solomon Andrews (1806–1872) of Perth Amboy flew his dirigible airship, the *Aereon*, over the city, causing great disbelief and excitement among its citizens. Throughout that summer, Dr. Andrews flew his remarkable invention, the first of its kind, over the Raritan River and Bay. Sure of its ability to help bring the Civil War to a speedy conclusion, he wrote the State Department and even Abraham Lincoln himself, in the hopes that the government would fund the construction of more airships like the *Aereon* in order to drop bombs on the South from the air. His request was never taken seriously, though he continued to fly. In the spring of 1866, he successfully flew a second airship, *Aereon II*, over Manhattan, landing in Oyster Bay, Long Island, leaving residents of New York shocked and confused by what they had seen. (Courtesy of John Kerry Dyke.)

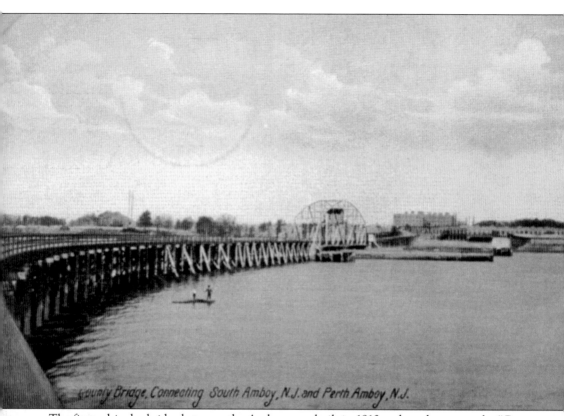

County Bridge, Connecting South Amboy, N.J. and Perth Amboy, N.J.

The first vehicular bridge between the Amboys was built in 1910 and was known as the "County Bridge." With its completion, residents could, for the first time, walk across the Raritan where the river met the bay. On October 4, 1918, the residents of South Amboy and the surrounding area had to do just that when the T.A. Gillespie Shell Loading Plant, located in Morgan near Cheesequake Creek, was destroyed in a series of explosions that rocked the area for three days. Set off by an unknown spark, the munitions, intended for the western front in Europe, sent panicked residents fleeing to nearby Perth Amboy over the narrow County Bridge. (Courtesy of the Historical Society of South Amboy.)

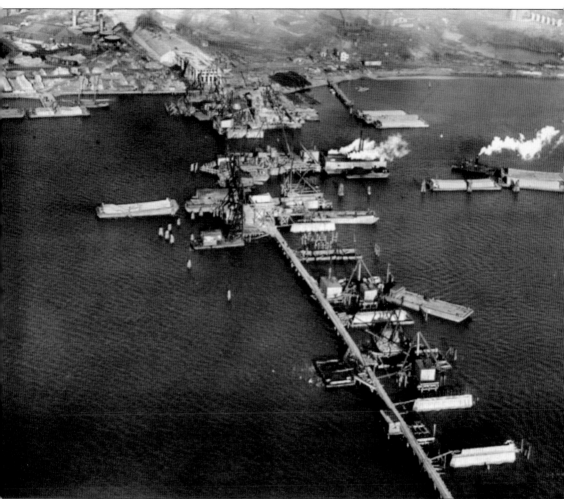

After World War I, car ownership in America tripled, and the old County Bridge soon showed itself to be inadequate. In addition to the increased volume, the weight of new trucks then appearing on the roads began to put a strain on the bridge, and demand for a new bridge grew quickly. In this aerial view of the Perth Amboy side of the river, construction of the new Victory Bridge is focused on the river's north channel, where its state-of-the-art swing bridge is being installed. (Courtesy of the New Jersey Department of Transportation.)

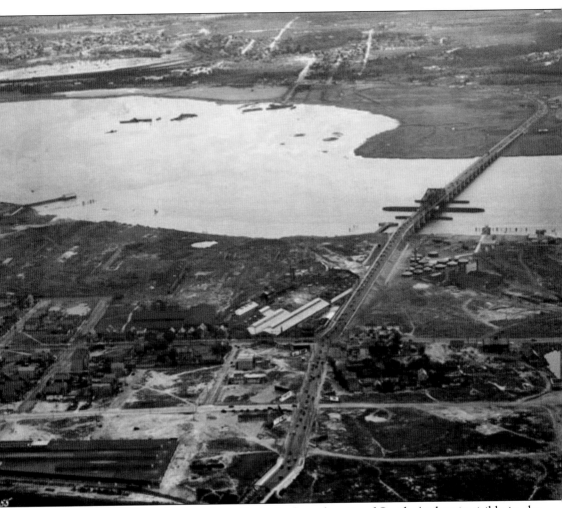

Looking south across the river from Perth Amboy, the city of South Amboy is visible in the upper left. The Victory Bridge was built to the west of both cities, extending out from Kearney's Point in Sayreville. East of this point, the river widens greatly as it empties into the Raritan Bay, making a more direct connection between the cities less favorable. When completed, the 360-foot Victory Bridge was the longest bridge of its kind in New Jersey. (Courtesy of the New Jersey Department of Transportation.)

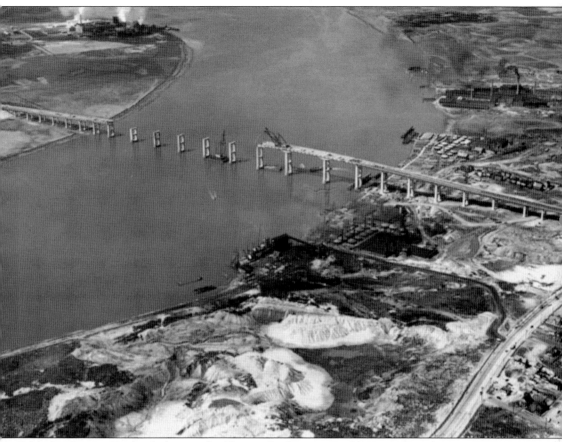

Like the County Bridge before it, the Victory Bridge too quickly proved inadequate as more and more Americans took to the roads, and another, larger bridge was constructed just west of the low swing bridge. The Thomas A. Edison Bridge was designed by Morris Goodkind, chief engineer of the bridge division of the New Jersey State Highway Department for over 30 years, beginning in 1925. Goodkind was also responsible for the iconic design of the Pulaski Skyway, as well as the College Bridge in on Route 1 in New Brunswick, which was later named for him. For the Edison Bridge, a federal requirement of 135 feet of clearance above the main channel posed unique challenges for Goodkind. Long approaches would be needed to keep the road grade within acceptable limits. To meet these demands, Goodkind and his team of engineers agreed upon an ambitious design, calling for the longest and heaviest deck plate–girder bridge ever built in the United States. (Courtesy of the New Jersey Department of Transportation.)

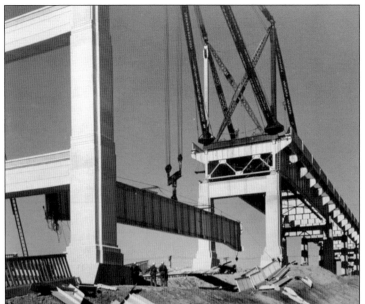

The final design called for a bridge 4,391 feet in length, with 29 total spans, 9 of which would be over the river. Here, a girder is being lifted into place over one of the approaches to the river. The record-breaking main girder, situated above the north channel of the river, was comprised of three continuous span girders, a 250-foot span flanked by two 200-foot spans. (Courtesy of the New Jersey Department of Transportation.)

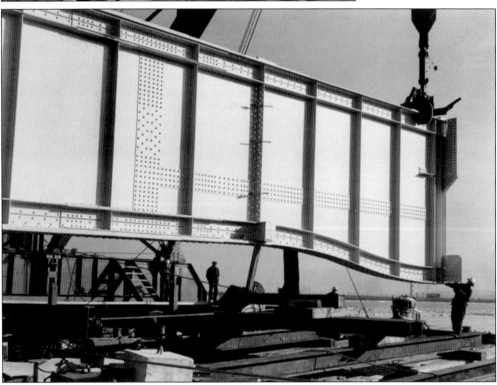

Only two bridge builders in the United States were capable of taking on the job, as girders of this proportion had never before been constructed. The contract went to Bethlehem Steel Company's Fabricated Steel Construction Division. With an unprecedented weight, length, and depth, the girders required specially constructed railcars for the trip from the factory to the docks at Jersey City, where they were then loaded onto barges for delivery to the bridge site. (Courtesy of the New Jersey Department of Transportation.)

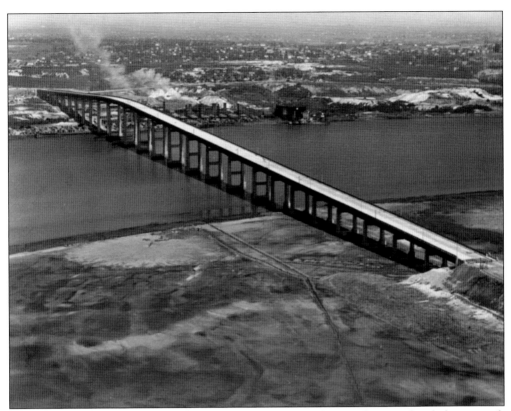

With girders so large that they could not be lifted into place with even the slightest wind, the Edison Bridge was a marvel of modern engineering. It forever altered the landscape of the Raritan, and its majestic presence on the river could not be ignored. The bridge was permanently opened to traffic on November 20, 1940. Three men were killed in falls from the bridge during its construction. (Courtesy of the New Jersey Department of Transportation.)

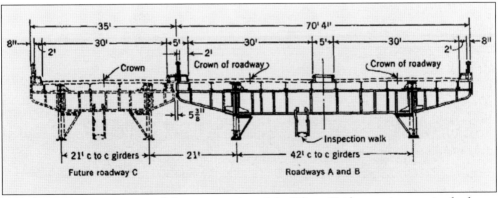

One the most unique aspects of the construction of the Edison Bridge was its capacity for future growth. The bases of the piers were built with added room for future roadways to be constructed alongside the original spans, as seen here. This feature would not need to be utilized right away, however, because on July 30, 1954, the Driscoll Bridge, built alongside the Edison Bridge, was opened to traffic. (Courtesy of the New Jersey Department of Transportation.)

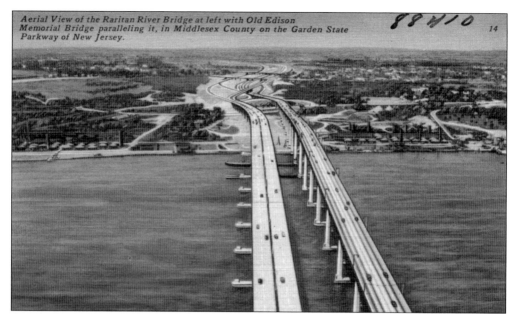

An idealized, illustrated postcard shows the two sister bridges, the new Driscoll Bridge and the "old" Edison Bridge, landing gracefully in Woodbridge Township. The Garden State Parkway cuts a wide swath through the land, as industries are relegated to the banks of the Raritan. Circulating during the postwar housing boom, this postcard promoted not only the parkway, which was an integral part of New Jersey's suburbanization, but also the promise of a peaceful countryside quietly profiting from the economy of a mighty river. (Courtesy of the Boston Public Library.)

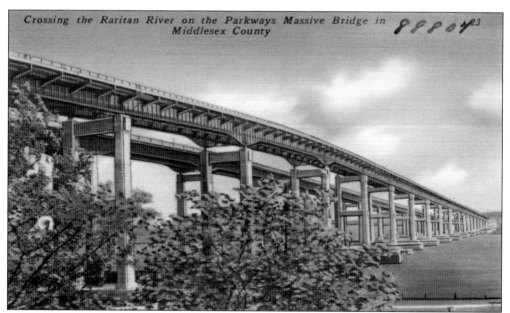

This postcard view of the newly constructed Driscoll Bridge from the Woodbridge shoreline shows the jarring height of the bridges, accurately describing the parkway's bridge as "massive." The Driscoll Bridge matched the Edison Bridge's 135-foot clearance. (Courtesy of the Boston Public Library.)

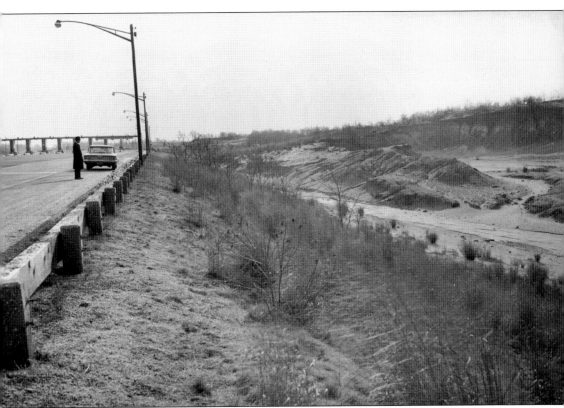

The Edison and Driscoll Bridges brought many travelers through a new landscape for the first time as they eased the geographic separation between north and south Jersey caused by the Raritan. Before the bridges, clay mining dominated Kearney's Point, and its effects on the land were visible for decades, as pitch pines and other vegetation slowly reclaimed the barren pits left in the wake of mining. In this photograph, an unidentified motorist stops on the shoulder of the Garden State Parkway in Sayreville, looking out at the clay pits in front of him. The construction of the Driscoll Bridge and the extension of the parkway south of the Raritan initiated new home construction all along its path, as young families eagerly escaped the dirty, crowded, industrial cities north of the river. The clay pits of Sayreville and the farmlands beyond were rapidly transformed into idealized suburban spaces, encapsulating the hopes and dreams of New Jersey's white urban population. (Courtesy of the Sayreville Historical Society.)

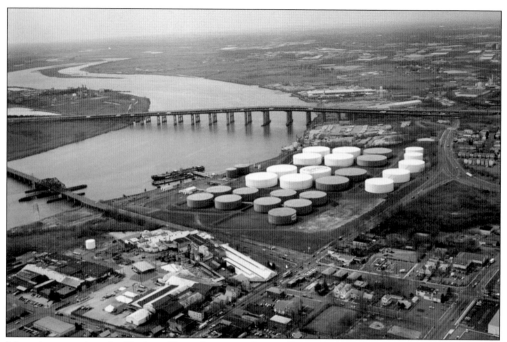

Motorists crossing the Raritan River between Sayreville and Woodbridge were confronted by a grey, almost dreary landscape, one completely overtaken by industry. On the north side of the river, the bridges cradled oil tanks, and on the south side, visible beyond the bridges, stood National Lead. All around were clay pits, sand hills, coal yards, and rail yards. (Courtesy of the Library of Congress, Prints and Photographs Division.)

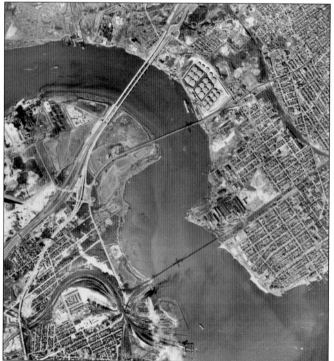

Now with three vehicular bridges and one railroad bridge, the Amboys were better connected than ever before, as was northern New Jersey with the shore. A greater capacity for trucking facilitated the growth of the industries here at the mouth of the river and decreased their reliance upon water transportation. Clay and sand were now being trucked up to New York City from the south banks of the Raritan. The flow of industrial waste from National Lead, seen here, shows that what once was a vital transportation route had become instead a toxic dumping ground. (Courtesy of the Sayreville Historical Society.)

Initially named the College Bridge when it was completed in 1929 and later renamed the Morris Goodkind Bridge in 1969, after its engineer, the bridge carried Route 1 over the Raritan at New Brunswick. Its Art Deco design is a reflection of the era in which it was built, and when compared to the Edison and Driscoll Bridges, it shows Goodkind's versatility as an engineer. (Courtesy of the New Brunswick Free Public Library.)

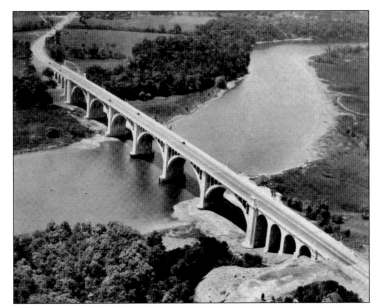

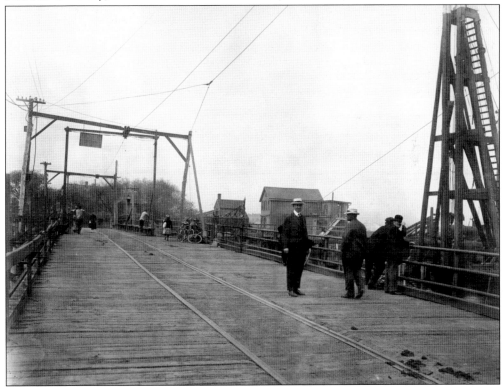

The first bridge over the South River at the town of Washington was built in 1860, nearly 30 years after the construction of the Washington Canal, indicating the greater importance of the rivers to the prosperity of the small community. The first bridge was privately owned and a toll was levied for its use: 1¢ for any person on foot, 2¢ for any person on a horse or mule, and 6¢ for a carriage carried by four horses, mules, or oxen. (Courtesy of the South River Historical & Preservation Society.)

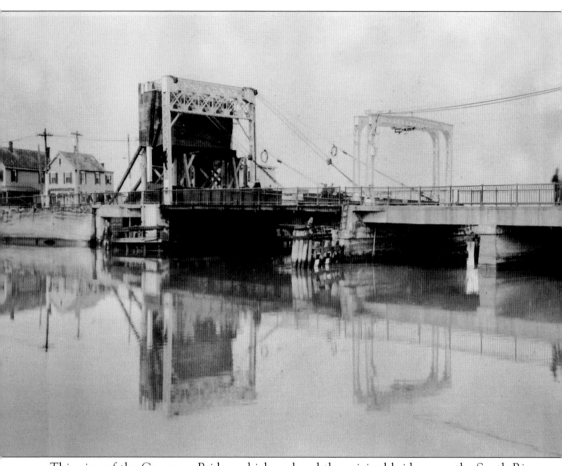

This view of the Causeway Bridge, which replaced the original bridge over the South River, show a much sturdier structure better suited for vehicular traffic. (Courtesy of the South River Historical & Preservation Society.)

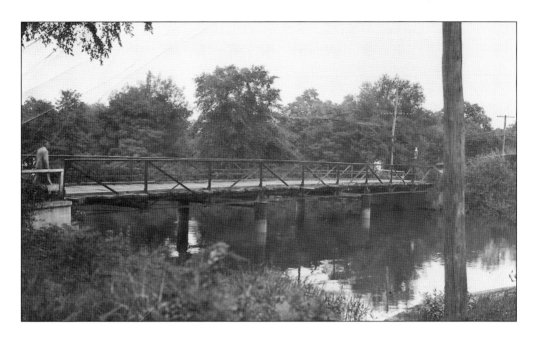

Prior to the bridge being built at the town of Washington, the only crossing over the South River was located miles upstream, where Lawrie's Road crossed the river, near the village of Old Bridge. Sloops once traveled as far as this bridge, where they picked up timber, grain, produce, and, later, bricks, bound for New York City. In the photograph above, a man strolls over the bridge in what appears to be a quiet rural setting, far removed from the industry near the Raritan. Below, local children enjoy swimming in the South River, perhaps jumping into the water from the bridge above. Looking east up Lawrie's Road, the water tower in the distance belongs to the Quigley Company, makers of enamel brick. (Both, courtesy of the Sayreville Historical Society.)

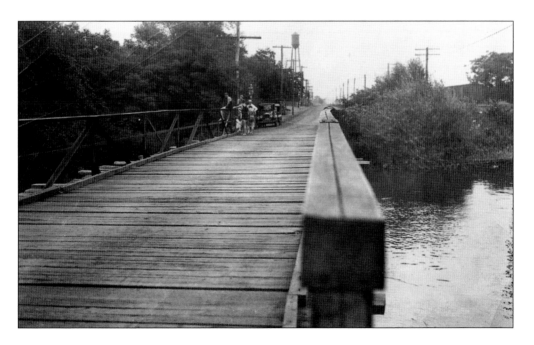

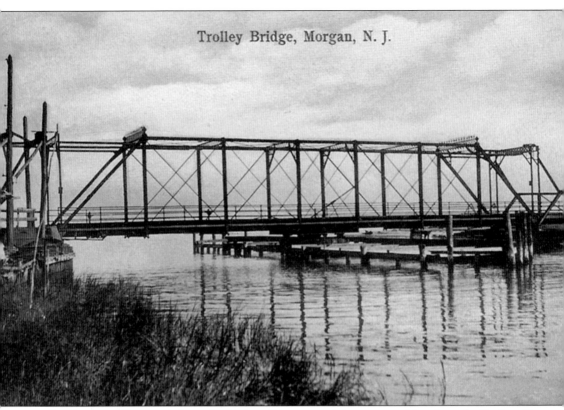

Trolley Bridge, Morgan, N. J.

For those traveling south from the Raritan River toward the communities along the Raritan Bay shore around 1900, the trolley was the way to go. This postcard shows the bridge that carried trolleys over Cheesequake Creek, where it spilled into the Raritan Bay. A small wooden bridge stood at the foot of Old Spye Road for those traveling by foot, but the trolley offered quick and reliable transportation into South Amboy, either for work at the city docks or a transfer to points beyond. The coming of the T.A. Gillespie Shell Loading Plant during World War I created many new jobs that brought workers in from points north and south, who used the trolley to commute to the plant in Morgan.

Four

SINCE THE TIME
OF THE FLOOD

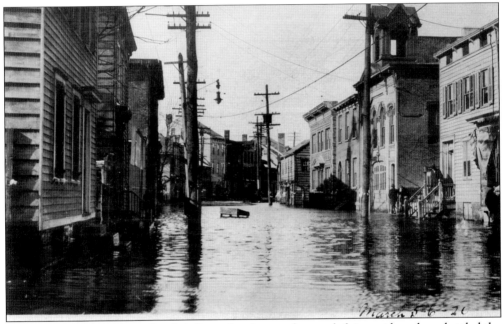

New Brunswick has always flooded. Since the city was first settled, its residents have battled the rising waters of the Raritan after large storms, nor'easters, hurricanes, and historic rainfalls. Floods were such a part of life in New Brunswick that the alma mater of Rutgers University, written in 1873, refrains: "On the banks of the old Raritan, my boys, where old Rutgers ever more shall stand, For has she not stood since the time of the flood, On the banks of the old Raritan." One memorable flood occurred March 5–6, 1920. In what was referred to in local newspapers as a freshet, the flooding of a river caused by heavy rains coupled with melting snows, the Raritan flooded much of New Brunswick. The rain fell hard and fast, causing the river to rise so rapidly that the force with which it moved downstream caused a 100-foot portion of the County Bridge connecting the Amboys to wash away when it was struck by floating ice from New Brunswick, forcing the closure of the bridge for a time. Two trolley cars that were on the bridge stalled after becoming submerged in the rapidly rising waters, and they remained frozen to their tracks after the waters subsided.

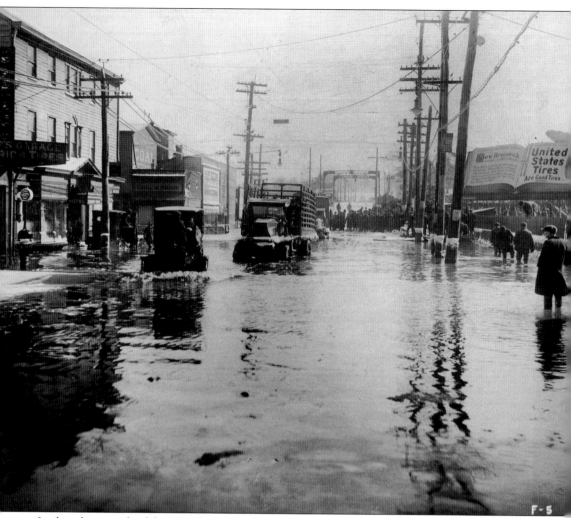

In this photograph of the 1920 freshet, residents appear more than willing to take to the streets. They were probably less concerned than they were anxious for the river to return to its banks and for life to get back to normal. The Albany Street Bridge was a vital link to and from the city, and it would take a greater flood than this to keep residents off it. (Courtesy of the New Brunswick Free Public Library.)

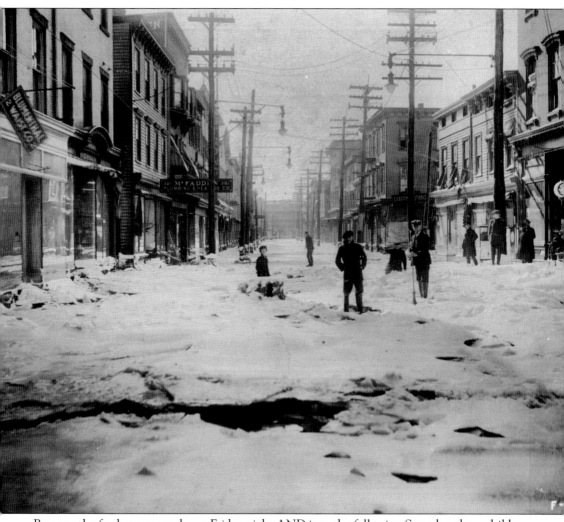

Because the freshet occurred on a Friday night AND into the following Saturday, these children on Burnett Street were probably disappointed that they would not miss a day of school. But the streets of New Brunswick must have peaked their sense of adventure that Saturday, as large chunks of ice were carried into the city by the rising waters and deposited in the streets overnight, creating what must have been an unfamiliar and exhilarating landscape for a child. (Courtesy of the New Brunswick Free Public Library.)

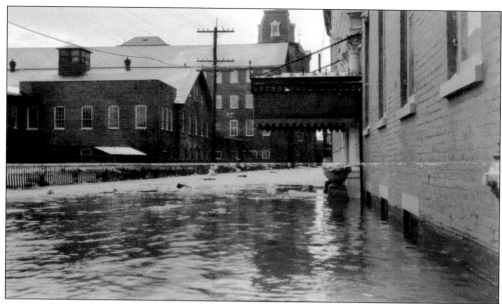

In 1925, New Brunswick was impacted by another freshet. This view of the Hotel Klein, a 50-room hotel located at 12 Albany Street, shows sheets of ice floating in the receding floodwaters. The line of ice clearly visible along the fence, and faintly visible along the side of the building on the right, indicate the peak height of the flood, which rose just above the urns on the steps at the entrance to the hotel. (Courtesy of the New Brunswick Free Public Library.)

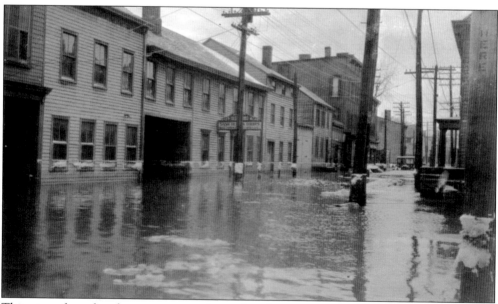

This view of another downtown street shows that the water rose just above the window sills of the buildings on the left. The windows were likely not watertight enough to keep the freezing water out, and the buildings along this street probably suffered extensive damage in this flood. (Courtesy of the New Brunswick Free Public Library.)

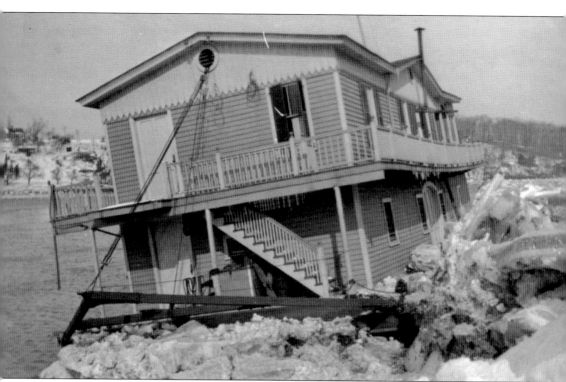

The 1925 flood caused the boathouse that had been secured to the Albany Street Bridge for decades to break away under the weight of floating ice and rushing water. Frozen in place, residents would have to wait until the next thaw to repair and reattach the boathouse. (Courtesy of the New Brunswick Free Public Library.)

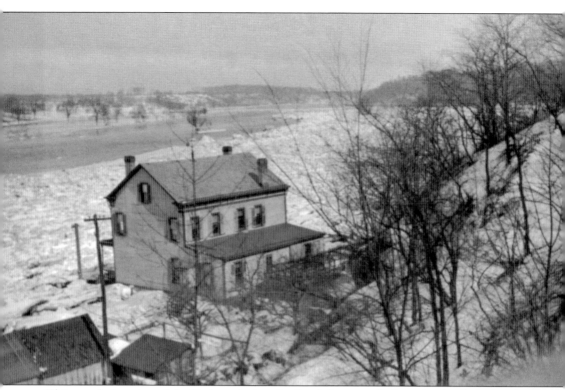

This east-facing view of the Raritan during the flood shows swelled riverbanks choked with ice between rolling, snow-covered hills. Such conditions, while quite lovely and surreal all at once, completely halted river traffic, putting an economic strain on the industries that relied upon the river, many of which probably suffered from flood damage as well. (Courtesy of the New Brunswick Free Public Library.)

The April nor'easter of 2007 caused the worst flooding the Raritan had seen since Hurricane Floyd. The two-day storm, which dumped between two and nine inches of rain throughout the state in what was one of the wettest periods on record in New Jersey, caused the river to flow up into Route 18, which was under construction at the time, undergoing improvements meant to help ease the effects of floodwaters on the highway. (Courtesy of the New Brunswick Free Public Library.)

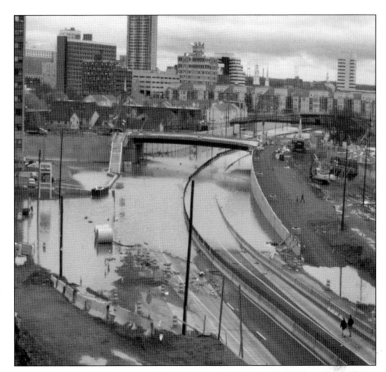

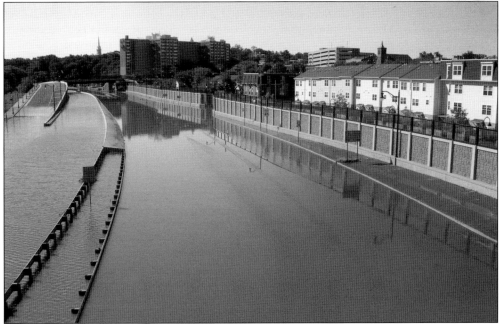

When Hurricane Irene struck New Jersey in August 2011, the first hurricane to directly hit New Jersey since 1903, many residents of New Brunswick were reminded of Hurricane Floyd. Irene's floods, unfortunately, rose slightly higher than Floyd's. Route 18 was constructed through New Brunswick in the 1980s over the filled-in Delaware and Raritan Canal, and the highway almost appeared to have reverted back to a canal in the flooding caused by Irene. (Courtesy of the New Brunswick Free Public Library.)

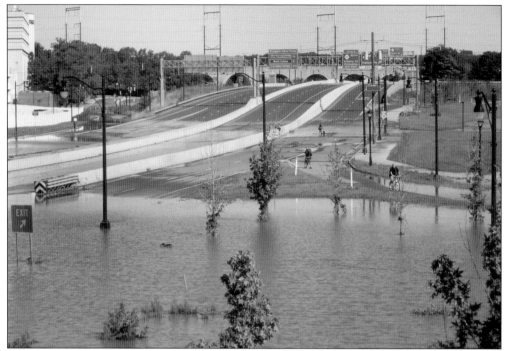

Flooding from Hurricane Irene was not a single event in New Brunswick. Over the course of the storm, the waters rose and then receded with each coming tide, first filling low areas along the river, such as Boyd Park, seen here. (Courtesy of the New Brunswick Free Public Library.)

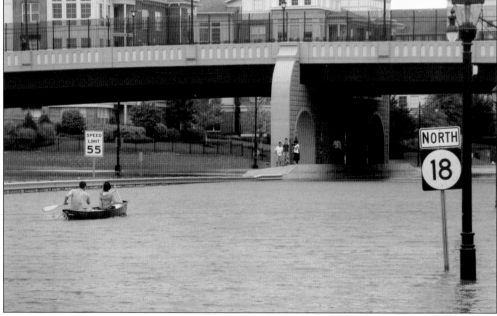

Despite the destruction caused by floodwaters, as images of storms past and present show, there is an element of excitement to the floodwaters of the Raritan and the unique ephemeral opportunities they give to residents. For instance, this couple probably never imagined they would ever enjoy the opportunity to canoe up Route 18. (Courtesy of the New Brunswick Free Public Library.)

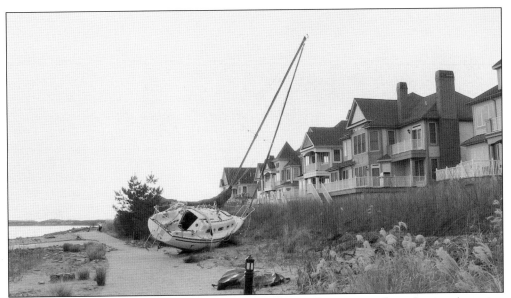

When Hurricane Sandy hit the Jersey shore in October 2012, it came in from the east, battering the coast with unprecedented force. It was not a major rain event like most of the past storms that have affected the Raritan, with floodwaters draining down from upstream. Instead, the power of Hurricane Sandy pushed seawaters inland with a surge so high it left this sailboat wrecked on the South Amboy shoreline. (Courtesy of James Creed.)

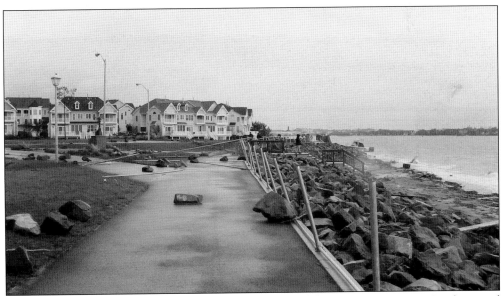

At the waterfront park on the border of South Amboy and Morgan, Hurricane Sandy moved into the Raritan Bay with such intensity that these heavy boulders were actually forced up the embankment and moved over the walkway into the grass. (Courtesy of James Creed.)

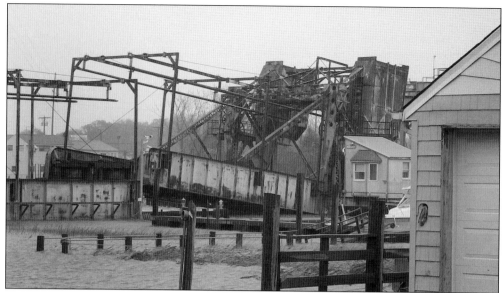

At Cheesequake Creek, the surge moved in well before Hurricane Sandy made landfall, pushing the waters of the Raritan Bay up into the railroad bridge over the creek many hours before the storm even hit, quickly shattering the record flood levels set by Hurricane Irene the year before. (Courtesy of James Creed.)

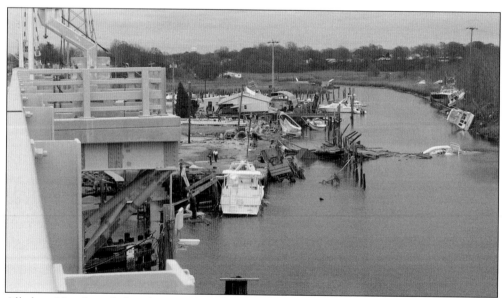

All along New Jersey's shoreline was complete destruction in the wake of Hurricane Sandy. The boats secured in the marinas at Cheesequake Creek were tossed around like toys and dropped back into the creek when the waters from the bay receded. This view of the creek from the Route 35 bridge facing inland shows not a boat undamaged by the storm. Most appear to have been wrecked beyond repair. (Courtesy of James Creed.)

The Great Beds Lighthouse survived the hurricane but not after sustaining serious damage. Its glass was shattered, and its door was ripped from its hinges. Most of the railing that had surrounded the lighthouse was lost, but the structure remained intact. The likeness of the lighthouse appears on the seal of the City of South Amboy. (Courtesy of James Creed.)

The Old Orchard Shoal Lighthouse was not so lucky. It had withstood 119 years of storms, but Hurricane Sandy's storm surge proved too great a match for the 51-foot-high, 35-foot-wide, cast-iron lighthouse. Built in 1893 in the "spark plug" style, the lighthouse was manned until 1955. Nothing remained after the hurricane but a mound of riprap and concrete, with the lighthouse lying in pieces at the bottom of the bay. The Verrazano-Narrows Bridge is visible across the Raritan Bay. (Courtesy of James Creed.)

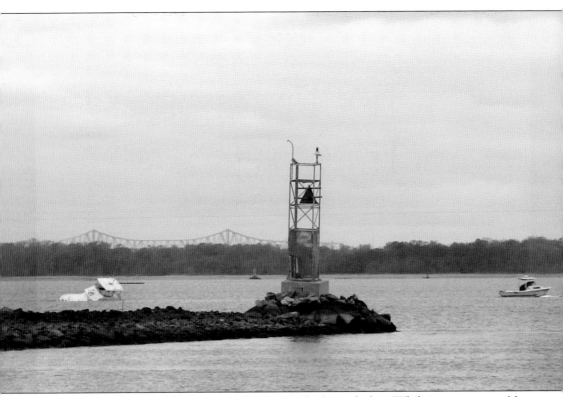

Hurricane Sandy was unlike any storm the Raritan had seen before. While in past storms, New Brunswick and other communities farther up the river had sustained the most damage from floodwaters, Sandy focused her might on the communities closest to the ocean, near the mouth of the Raritan River. In this case, rainwater did not collect upstream and force its way into the streets of New Brunswick, as had almost always happened in the past. Instead, the ocean itself pushed its way up into the mouth of the river, causing devastation at Perth Amboy's historic waterfront and submerging entire neighborhoods in South Amboy, Sayreville, and everywhere along the South River. This view of the jetty at Cheesequake Creek after the storm shows the Outerbridge Crossing in the distance, connecting Perth Amboy with Staten Island, with a half-sunken boat resting in the bay. (Courtesy of James Creed.)

Five

THE PRIDE OF ITS CITIZENS

Since the Lenni Lenape first inhabited this region, the waters of the Raritan had been a treasured source of recreation and relief during the warm summer months. This sketch of Morgan Beach appeared in *Frank Leslie's Illustrated Newspaper* on September 2, 1876. The West Side Relief Association ran a mission here for the benefit of the poor women and children living in New York's West Side tenements. At the cost of $1 for a child and $3 for a woman, the mission provided a week's stay on the beautiful Raritan Bay, near the mouth of the river, to offer relief from the city and restore their health. (Courtesy of the Sayreville Historical Society.)

At Kearney's Point in Sayreville, before the coming of National Lead in 1934, when clay mining was the dominant industry, there was room enough for cattle and other livestock to roam the landscape. This picture from the 1910s shows cattle grazing near the present location of the Garden State Parkway. (Courtesy of Anna Harris Friberg.)

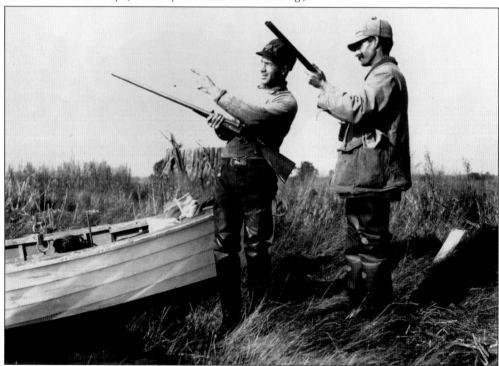

Hunting was once a popular form of recreation along the Raritan. In this photograph, D.J. Fisher, of the Fisher family, owners and founders of the Sayre & Fisher Company, hunts with a companion, presumably for ducks, in the marshes of the river in Sayreville. Fishing and crabbing were also popular sports in this area. (Courtesy of the Sayreville Historical Society.)

Gustav Bartz immigrated to South River from Germany in the 1880s. Working as a laborer, mechanic, and machinist, he found time to build this pleasure boat, the *Anna May*, which he made great use of on the South and Raritan Rivers. On October 16, 1912, the *New Brunswick Times* wrote, "Gustav Bartz's pleasure motor boat Anna May, which sank a few days ago because of the ropes being too short, has been entirely repaired. Mr. Bartz took a party up the Hudson River on Sunday in the launch and the party enjoyed the trip immensely viewing Uncle Sam's fleet." (Courtesy of Ed and Stephanie Bartz.)

Gustav Bartz ran a number of excursions with the *Anna May* for residents of the South River. In the summer of 1912, the *New Brunswick Times* wrote, "The members of Mrs. Wilbur Conover's Sunday school class with their friends enjoyed a delightful sail down the bay last night as far as Boynton Beach on Bartz' launch, where they landed and enjoyed the dancing." Boynton Beach, on the Arthur Kill in Woodbridge, was once a popular retreat for residents. (Courtesy of Ed and Stephanie Bartz.)

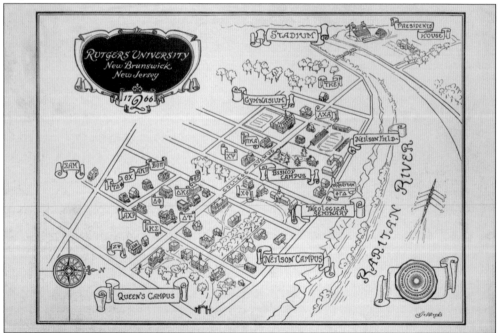

This 1892 map of Rutgers University prominently features the Raritan River. The school's history was inextricably linked to the Raritan. (Courtesy of Ed and Stephanie Bartz.)

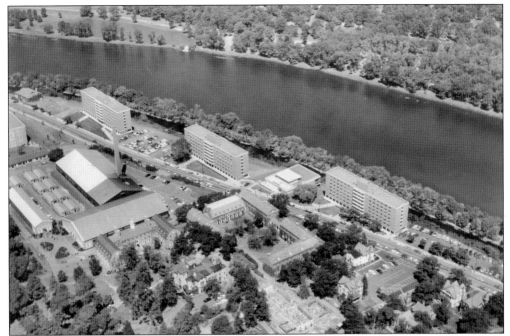

While many of the products made on the Raritan were shipped to far-off ports, sometimes they only had to travel a short distance. This 1958 aerial publicity photograph, used by the Sayre & Fisher Company, shows newly constructed Rutgers dormitories, built along the banks of the Raritan with bricks from the Sayre & Fisher plant in Sayreville. (Courtesy of the Sayreville Historical Society.)

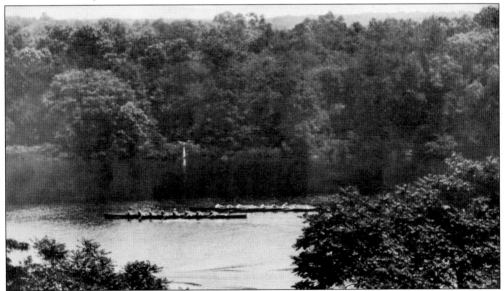

In 1864, rowing became the first organized sport at Rutgers University. In 1876, a floating boathouse was built for the crew team at the Albany Street Bridge. It washed away in a flood in 1882. The current boathouse, built in 1952, sits on the river just east of the Albany Street Bridge. This 1938 photograph shows the Rutgers crew team practicing on the Raritan. (Courtesy of the Sayreville Historical Society.)

Dan Hyland was born in 1920 and grew up in New Brunswick, where he spent much of his free time on the Raritan in his rowboat *Putt Putt*. This photograph was taken on Crab Island in Sayreville, about six miles from his home in New Brunswick. When Dan was just two years old, Gertrude Ederle broke the 440 yard swimming record to defeat Hilda James of England, and thousands of spectators filled the banks of the river in New Brunswick to watch the event. When swimmers complained of a sour taste, scientists soon declared activities on the river to be a public health risk, and all organized aquatic recreation was halted on the Raritan. A chemical and biological survey conducted by the Department of Water Supplies and Sewage Disposal of Rutgers University concluded in 1928 that it was "too dangerous to swim in the Raritan River from the town of Raritan to Perth Amboy." (Courtesy of Alison Hyland.)

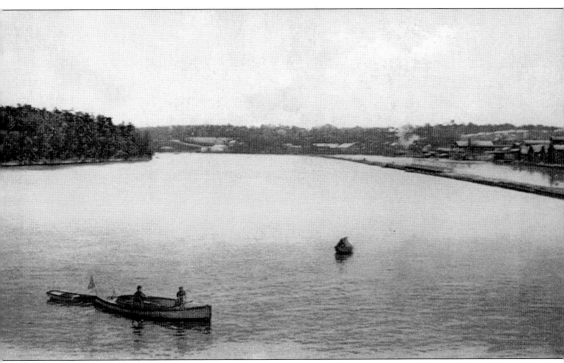

While great boating and other aquatic events brought throngs of spectators to the waterfront, the Raritan still offered boaters a quiet respite from the noise and grime of its industrial cities, as this 1921 postcard shows. Facing east, this view from the Albany Street Bridge shows the towpath of the Delaware and Raritan Canal to the right, with coal sheds and other industries behind it. While the Raritan still looked to be a pristine and healthy river, appearances were deceiving. Under the surface, the Raritan was in great distress. For nearly a century, the river had suffered from the uncontrolled and accelerated disposal of toxic waste, and enormous population growth generated a bourgeoning, unregulated flow of sewage into its waters. By the 1920s, the Raritan River was in great trouble. (Courtesy of the New Brunswick Free Public Library.)

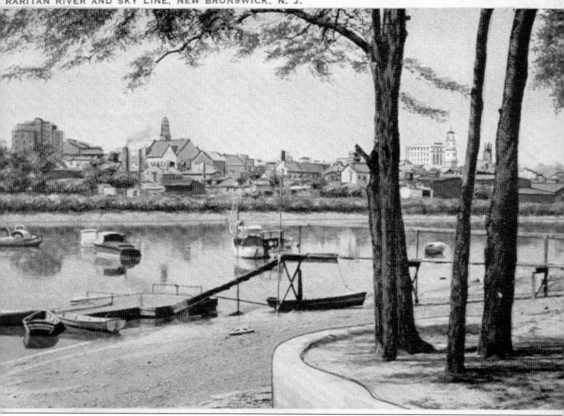

Industry flourished on the Raritan, building New Brunswick into a city with a sizable skyline that looked almost quaint from Highland Park, just across the river. Recreation flourished on the river alongside industry, but theirs was a precarious relationship. Cutlassfish, known locally as frostfish, were peculiar to the Raritan, and well known to the locals of all ages who fished its waters. American shad had once run thick in the Raritan, and residents, many of them children, caught shad in great numbers to be hawked in the streets of New Brunswick. Most often salted or pickled, for generations, shad was a common local delicacy. But by the 1920s, pollutants had caused a catastrophic decline in fish and shellfish populations, effectively putting an end to fishing in the Raritan. The waters of the Raritan belonged to industry. (Courtesy of the New Brunswick Free Public Library.)

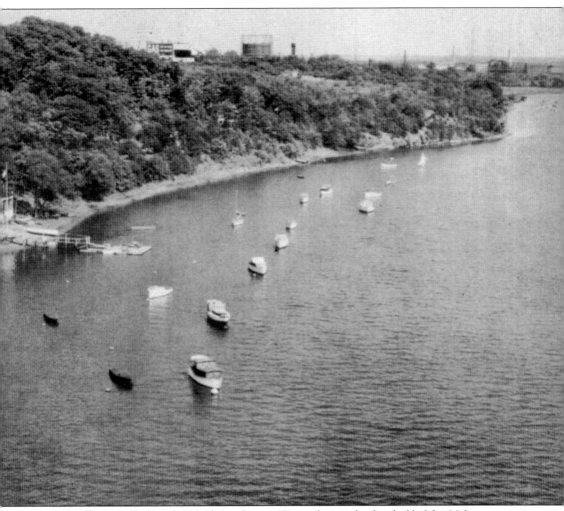

Recreational boating declined in the lower Raritan River during the first half of the 20th century, and, thus, so did membership in boat clubs. The New Brunswick Boat Club had been the site of nonstop boat races until pollution made them no longer a pleasure. Hulls turned black in the dirty water, and foul odors replaced fresh air. This 1938 view of the Raritan Boat Club in Edison shows a sparse number of boats in what appears to be a beautiful river. (Courtesy of the Sayreville Historical Society.)

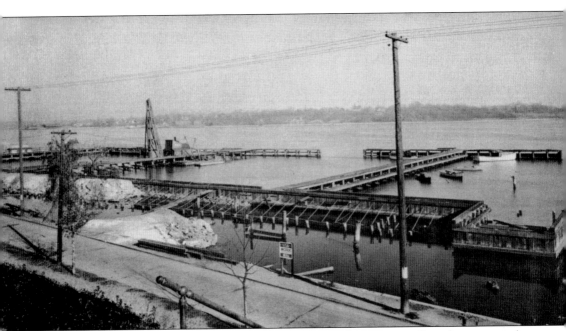

In this 1938 photograph, the Perth Amboy city docks sit almost empty. Once home to a robust and vibrant oyster industry, pollution ravaged the great oyster beds near the Amboys. In and around Perth Amboy, oil refineries gradually overtook the waterfront, and colossal oil tankers replaced the fishing boats and oyster sloops that once ruled the city's modest docks. (Courtesy of the Sayreville Historical Society.)

With increased urbanization came increased surface drainage, which gradually intensified along the Raritan without much notice, until the 1930s, when the number and size of drainage outfalls became visually appalling. By then, the river was already in crisis. Groundwater recharge decreased with the spread of impervious surfaces such as roads, parking lots, and buildings, reducing the water flow in the small streams that had once fed into the Raritan and the growing number of automobiles contaminating the surface drainage that was fed directly into the river. In 1930, a dam across the Raritan was proposed between New Brunswick and Highland Park. Long desired by residents, it would maintain the water above at high tide level, creating an inland lake for bathing, boating, and other aquatic sports that would be protected from the polluted waters downriver. This artist's conception shows the 475-foot-long dam, complete with a 20-foot-wide lock for recreational boats. Construction was estimated at the time to cost $170,000. The dam was never built, and surface drainage into the river continued to increase. Postwar suburbanization exacerbated this problem, which continues today. Between 1986 and 1995 alone, over 57 square miles of land in the Raritan River basin was converted to urban land use, bringing a rapid increase in impervious surfaces that directly impacted the river with runoff containing motor oil, gasoline, heavy metals, fertilizers, pesticides, and trash. (Courtesy of the Sayreville Historical Society.)

TABLE 7

AVERAGE DAILY SEWAGE FLOW

COMMUNITY	ULTIMATE DRAINAGE AREA (ACRES)	POPULATION 1930	1940	1955	AVERAGE DAILY SEWAGE FLOW (GALLONS) 1930	1940	1955
Raritan	619	5,300	6,100	7,300	1,705,000	2,000,000	2,250,000
Somerville	6,827	8,500	10,400	13,500	2,010,000	2,440,000	3,000,000
Manville	11,905	5,500	7,000	9,200	600,000	750,000	950,000
Bound Brook	2,335	8,000	10,000	13,000	950,000	1,200,000	1,500,000
Middlesex Borough	3,000	4,000	5,600	950,000	1,200,000
South Plainfield	9,090†	5,200	6,300	8,000	650,000	810,000
New Market	1,500	2,300	3,200	305,000	390,000
South Bound Brook	1,190	1,600	2,000	2,700	135,000	190,000	260,000
New Brunswick	5,864°	41,900	50,500	62,200	7,059,000*	10,174,000°	12,558,000°
Franklin and North Brunswick Townships	2,435	8,000	18,800	27,400	1,880,000	2,740,000
Milltown	970	3,600	4,600	6,200	530,000	598,000	725,000
Highland Park	2,492	8,300	11,800	17,200	1,175,000	1,525,000	1,975,000
South River	1,300	8,500	10,400	13,200	1,010,000	1,200,000	1,425,000
Sayreville	10,000	8,600	10,000	12,000	410,000	670,000	875,000
South Amboy	726	9,000	10,000	11,600	1,184,000	1,282,000	1,440,000
Perth Amboy	2,812	51,600	61,500	76,500	7,600,000	8,900,000	11,100,000
Woodbridge Township	1,029	4,800	5,700	7,000	500,000	600,000	700,000
Raritan Township	925	4,200	5,000	6,000	420,000	500,000	600,000
Piscataway	1,058	4,200	5,000	6,000	420,000	500,000	600,000
Totals for Communities	58,172	191,300	241,400	307,800	25,708,000	36,314,000	45,098,000
Industries	10,400,000	17,000,000
Total					36,108,000	53,314,000	

† Area given includes Middlesex Borough, South Plainfield and New Market.
° Includes Milltown, Franklin and North Brunswick Township.
* Includes Milltown.

In a 1930 report of the Port Raritan District Commission, it was stated that the Raritan River was essential to both life and industry and that its economic value was threatened with destruction at the hands of pollution from millions of gallons of raw sewage and industrial wastes. The report noted large deposits of filth, odors, and discolored and poisonous water, making the river a menace to public health and an active source of danger to the communities along its banks. This chart from the report shows that, in 1930, about 36 million gallons of sewage was being discharged into the Raritan each day! And that number was expected to rise to over 53 million gallons per day in just 10 years, with New Brunswick and Perth Amboy being the largest offenders. Industries flourished along the lower Raritan because of the convenient access to an abundant water supply and the transportation that it provided, in addition to its geographical location. But from the beginning, industries disposed of waste products by freely discharging them directly into the Raritan. (Courtesy of the Sayreville Historical Society.)

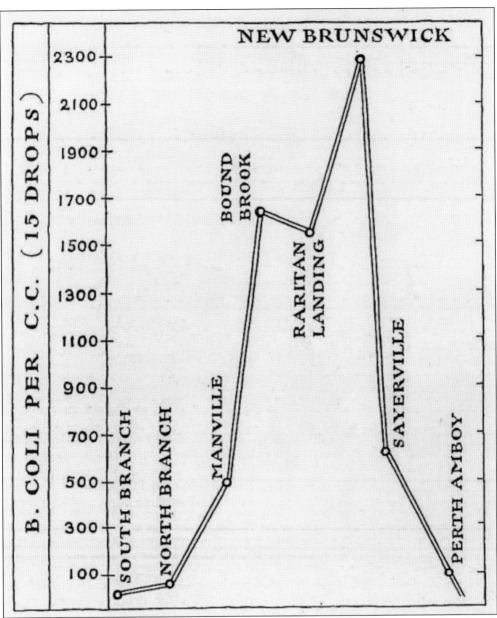

This chart from the 1928 pamphlet "Save the Raritan" by Richard Walsh shows the levels of b. coli found at various points along the river. Measurements of b. coli organisms were used at the time as an index of domestic pollution, as they were considered to be associated with disease-bearing bacteria. Earlier that decade, the New York City Health Department condemned swimming at city beaches because the water was shown to contain more than 30 members of b. coli per cubic centimeter. At the same time, tests showed that the Raritan River contained more than 2,050 members of b. coli at its most polluted point, a half mile east of New Brunswick. From there, the saltwater and tides dispersed pollutants. The Raritan was undoubtedly a menace to public health, but popular opinion at the time held to the belief that sewage disposal was a natural function of a river. (Courtesy of the New Brunswick Free Public Library.)

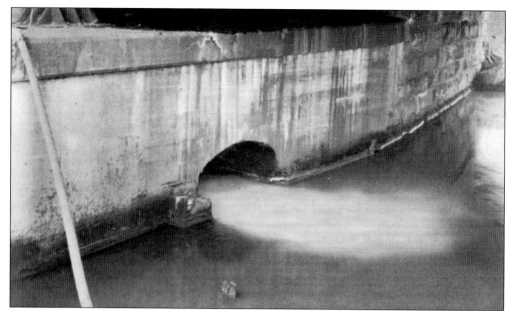

One of New Brunswick's main outfall sewers, pictured here in 1930, discharged untreated sewage into the Raritan for decades. The introduction of sewage treatment plants along the river improved the water quality, but real change would not come until 1972, with the Clean Water Act, which established national baseline pollution standards. (Courtesy of the Sayreville Historical Society.)

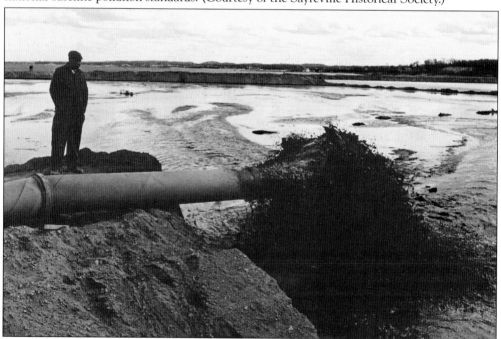

The coal loaded into Jersey Central Power & Light's E.H. Werner Power Station at South Amboy was pulverized into a powder and fed into burners that heated the plant's boilers, the steam from which turned two 25,000-kilowatt turbo generators. The ashes left behind were suctioned out, and the slag was then heated into a liquid that was piped directly into the Raritan. (Author's collection.)

Dye waste, which was regularly discharged into the river, killed fish and plant life. It also threatened residents who came in contact with the waters of the Raritan. Waste discharges such as this have been linked to cancer and genetic mutations, and the metal ions they contain can be absorbed by vegetation, which can threaten humans through ingestion. (Courtesy of the New Brunswick Free Public Library.)

Combined sewer systems collect rainwater runoff, domestic sewage, and industrial wastewater in the same pipe. During periods of heavy rainfall, they are designed to overflow, spilling untreated human and industrial waste, toxic materials, and debris into waterways. This recent image of a combined sewer overflow in Perth Amboy is doing just that, into the Raritan. The railroad bridge linking the Amboys is visible in the background. (Courtesy of the Raritan Riverkeeper.)

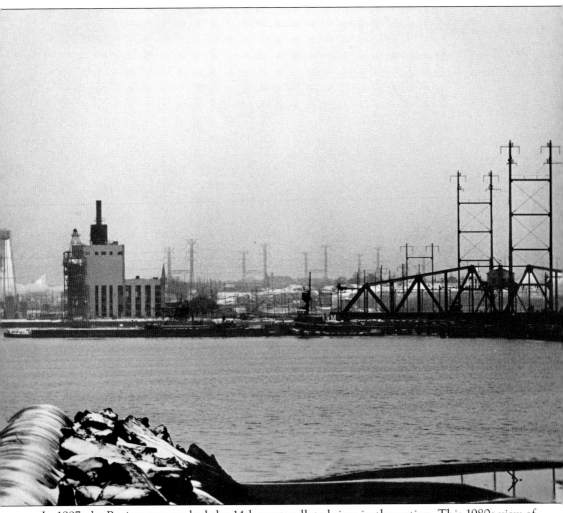

In 1997, the Raritan was ranked the 14th-most polluted river in the nation. This 1980s view of Jersey Central Power & Light's E.H. Werner Power Station in South Amboy, taken from across the river in Perth Amboy, shows a completely industrial environment at the mouth of the Raritan, unfit for recreation. The railroad swing bridge is open to allow the passage of a barge, and more power lines can be found than trees, while a pipeline feeds waste into the river. The proliferation of industry earned the lower Raritan River the unfortunate nickname of "the Chemical Belt." The past 30 years have seen the departure of industry, and regulatory actions taken during that time have stayed or reversed some of the worst surface and groundwater pollution, but the legacy of industry remains. Today, 24 superfund sites still drain into the river, but the river is on the mend, and its citizens are actively taking it back. (Author's collection.)

The RARITAN VALLEY

Home to 1.2 million people, the Raritan River basin covers 1,100 square miles that drain directly into the Raritan Bay. New Brunswick and Perth Amboy have been the commercial hubs of the region, but, as this 1928 map shows, the livelihood of many other population centers are directly linked to the Raritan and its revival. Over one million residents draw drinking water from the surface waters of the Raritan basin. Yet tests of the waters between New Brunswick and Perth Amboy in 2008 still showed levels of phosphorus, PCBs, DDD, DDE, DDT, chlordane, dioxin, dieldrin, heptachlor, benzoa pyrene, arsenic, cadmum, mercury, zinc, dissolved oxygen, and total suspended solids, all in violation of the New Jersey Department of Environmental Protection's parameters for clean water. Regardless, the river continues to improve. As former Rutgers University president John Martin Thomas (1871–1960) once proclaimed, "We made the Raritan River dirty, and it is up to us to make it clean." (Courtesy of the New Brunswick Free Public Library.)

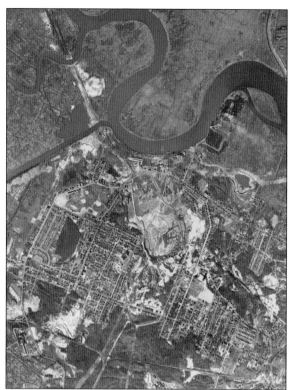

Not only has industry ravaged the health of the Raritan, it has also reshaped the land along its banks. This 1960s aerial of the Roundabout in Sayreville shows the tremendous impact of clay mining on the landscape. What were once 80-foot bluffs rising high over the river were reduced to holes in the ground over the course of 100 years. (Courtesy of the Sayreville Historical Society.)

Major's Pond in Sayreville was created by clay mining during the first decades of the 20th century. Once a hilly landscape near the Washington Canal, it was transformed into a pond by industry, as the clay within was fired into bricks and shipped out along the Raritan. The new homes at the top of this 1952 aerial were submerged during Hurricane Sandy when the Raritan flowed into the pond. (Courtesy of the Sayreville Historical Society.)

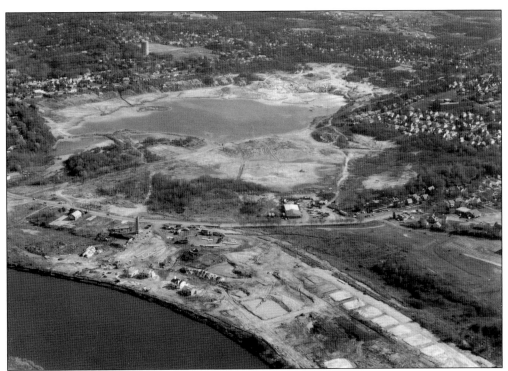

This south-facing aerial of the Roundabout from the 1980s shows the formation of another pond near the Raritan caused by clay mining. The Sayre & Fisher Brick Company's main plant once covered the entire waterfront in this image. It was eventually dismantled, and new housing construction can be seen taking its place. For the first time since the Industrial Revolution swept through the lower Raritan, people are moving back to the river. (Courtesy of the Sayreville Historical Society.)

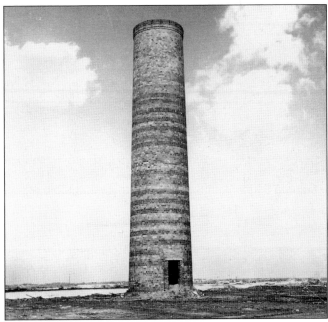

When the Sayre & Fisher plant was dismantled in 1970, one brick water tower was left along the river as a monument to the once mighty industry. The river can be seen behind the tower, and new housing has since been built all around the brick structure. However, it is still visible from the Raritan, where millions of bricks were once loaded onto schooners and barges waiting in the river. (Courtesy of the Sayreville Historical Society.)

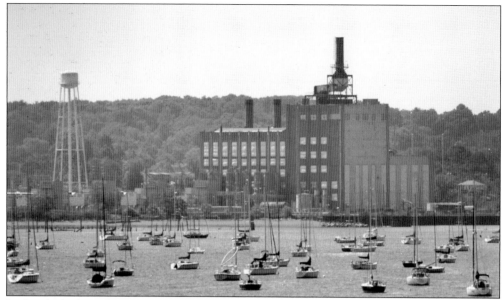

In South Amboy, the E.H. Werner Power Station now sits in quiet repose, slated for eventual demolition. As the waters of the river have improved with the decline and removal of industry, recreational sailboats now fill the Raritan between the Amboys. Railcars filled with coal no longer come to South Amboy's docks, and many of the sand hills and coal yards have given way to vegetation. (Courtesy of Verne James.)

Not all of the remnants of industry are unattractive, and some even have a unique appeal. The E.H. Werner Power Station was designed by the same architects responsible for the Empire State Building. Its Art Deco design can be seen from the water and remains a significant component of the Raritan River's cultural landscape. (Courtesy of Verne James.)

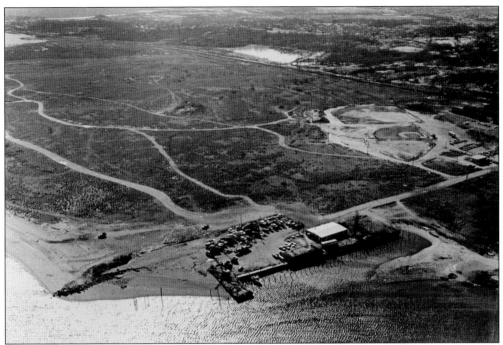

In an ambitious effort, the City of South Amboy has, in recent years, completely reimagined its waterfront. Once a vital ferry and steamboat port and highly industrial rail terminal, its residents once again have access to the Raritan. Schools, a public library, recreational facilities, and an expansive park now bring the public closer to the water than has been possible for generations. A public walkway along the beach and new housing offer views of the Raritan Bay that make its citizens justifiably proud of the waterfront that rightfully belongs to them. In South Amboy today, the Raritan is no longer the exclusive domain of industry. (Above, author's collection; below, courtesy of Verne James.)

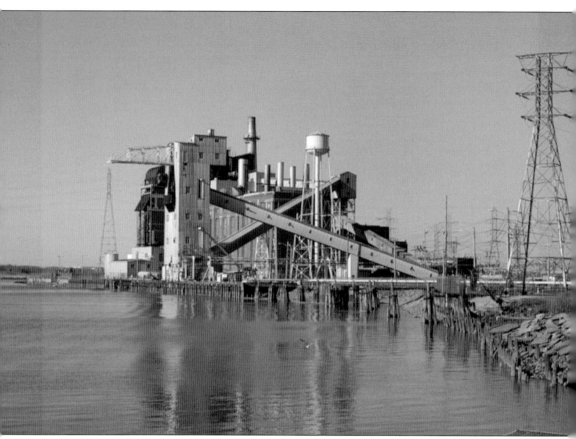

Like its sister powerhouse in South Amboy, the Jersey Central Power & Light Powerhouse in Sayreville, once capable of producing 100,000 kilowatts of electricity, now sits peacefully over the Raritan. This photograph was taken from the public boat dock at the end of River Road, which is also pictured on the cover of this book, though roughly 100 years earlier. Once part of the Minisink Trail, it was here that the Lenape crossed the river. Today, the waterfront at River Road is the site of a public park, boat launch, and dock, which offer sweeping views of the Roundabout, with salt marshes and landfills across the river and public access to the river, which had been impeded by the Sayre & Fisher Company for over a century. While everything around it has changed, the powerhouse remains as a remnant of a bygone industrial era and a landmark to recreational boaters navigating the river below. (Author's collection.)

Edgeboro landfill (above), located on the Raritan River in East Brunswick, between Sayreville and New Brunswick, was operated by the Herbert family from its beginnings in the 1950s until it was closed and the property sold to Middlesex County. The state's largest active trash dump, at over 200 acres, Edgeboro takes in over 500,000 tons of trash each year. On the north side of the river sit the ILR (below), Edison, and KinBuc landfills, the latter being a superfund site. While the steamboat passengers of the early 19th century passed through a pristine countryside marked by flat salt marshes on their way to New Brunswick, recreational boaters today pass through a valley of trash. In recent years, solar panels have been installed at Edgeboro. (Both, courtesy of the Raritan Riverkeeper.)

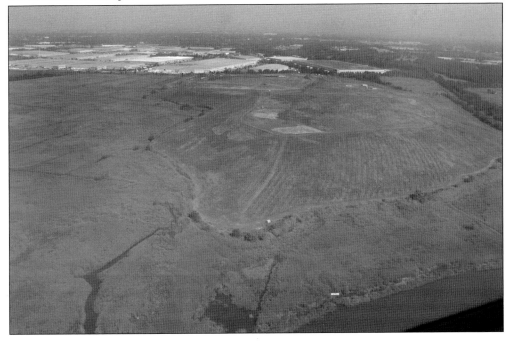

This 2006 photograph of Edgeboro shows an exposed riverbank that for many years shed plastic and other pieces of trash with every tide change. This uncontrolled source of pollution has since been corrected with the installation of riprap and the planting of trees. The efforts of environmental groups and public advocates are instrumental in the prevention of pollution sources such as this, caused by carelessness and neglect. (Courtesy of the Raritan Riverkeeper.)

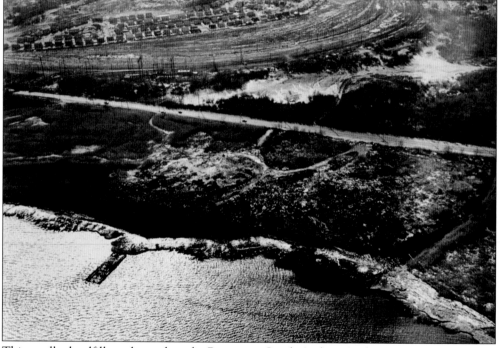

This smaller landfill was located on the Raritan in South Amboy. At the top of the photograph are homes, separated from the landfill by the tracks of the Pennsylvania Railroad. In the upper right are scars in the land from clay and sand mining. For many residents living along the Raritan, industry and pollution were a part of life and the river was not. (Author's collection.)

With a watershed of 1,100 square miles, all of the water in the Raritan River flows out to the Raritan Bay, but not before passing the Amboys. Any trash that makes it out of the countless streams and rivers that feed into the Raritan follows the same route, and much of it ends up on the beaches of the Amboys. This 2004 photograph shows residents picking up trash on the beach in South Amboy through the coordination of the Raritan Riverkeeper. Though it may have appeared to the volunteers that day that the citizens of South Amboy had a bad habit of littering on their beach, in actuality, nearly all of the trash that washes ashore in South Amboy originates upriver. In the case of floating trash, the towns at the mouth of the Raritan are simply victims of their own geography. (Courtesy of the Raritan Riverkeeper.)

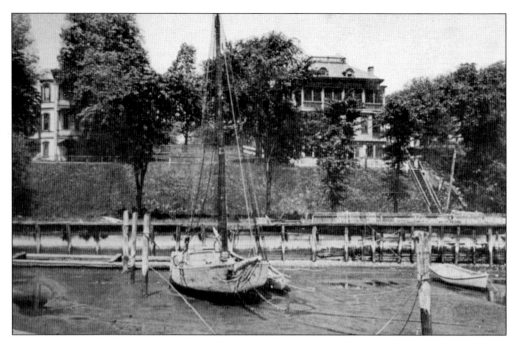

The Perth Amboy bluff, seen above around 1900, rises steeply from the water. This natural barrier has somewhat isolated the waterfront from the rest of the city, allowing it to retain much of its historical appeal. At the junction of the Raritan River and Arthur Kill, the Colonial port has maintained, to a degree, the atmosphere of a small fishing village. Despite challenges faced by pollution, the marina, seen below in 1960, has remained active to this day. The waterfront is also home to the Raritan Yacht Club, one of the oldest in the country, established in 1865. Visitors to the waterfront today can enjoy a brick promenade and a great number of Victorian homes situated along tree-lined streets. (Both, courtesy of John Kerry Dyke.)

In the decades following World War II, New Brunswick suffered from the urban decline that faced many American cities after the growth of the suburbs. Most of the city's white residents moved out, and it lost all seven of its downtown department stores. Faced with a crowded, deteriorating city, in 1974, Johnson & Johnson made the ambitious decision to build a new corporate headquarters in New Brunswick and spearhead the revitalization of the city. The new headquarters, pictured here from the river, was the centerpiece of the city's redevelopment. Designed by I.M. Pei and constructed between 1979 and 1983, the 16-story tower rises from a 12.5-acre site that includes six low-rise office buildings. No longer industrial, New Brunswick markets itself under the moniker "the Healthcare City." Today, its largest employers are Rutgers University, Robert Wood Johnson University Hospital, St. Peter's University Hospital, Johnson & Johnson, and the University of Medicine and Dentistry of New Jersey. (Courtesy of the New Brunswick Free Public Library.)

Recreational boating has returned even to what were the most polluted parts of the lower Raritan River. A new postindustrial "riverscape" is taking shape along the Raritan, and greater numbers of boaters are taking notice. Many factories have been dismantled, and industrial traffic has ceased, yet the great bridges remain, such as the Donald and Morris Goodkind Bridges, seen here carrying traffic high above the river along Route 1 between Edison and New Brunswick. (Courtesy of the Raritan Riverkeeper.)

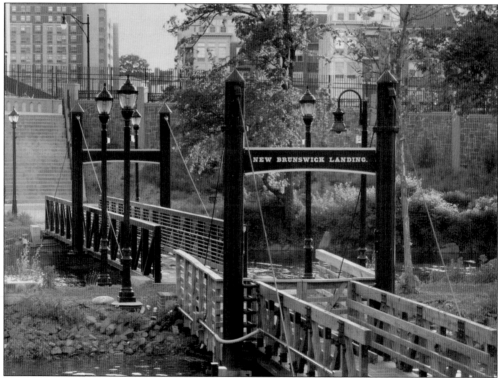

Once a bustling Colonial port where wheat, flax, flour, and produce from the surrounding countryside were loaded onto ships bound for New York City every day, New Brunswick's early riverside cityscape has been all but lost to industrialization and redevelopment. Today, however, recreational boaters can dock at the city's new marina and walk the streets of the small city, just as merchants and travelers did in preindustrial times. (Courtesy of the Raritan Riverkeeper.)

The loss of wetlands on the lower Raritan has had devastating ecological effects for the river. Once abundant along the river, many wetlands have been lost to industry. Even more have been lost to suburbanization. They are crucial to the ecological health of the river because of their filtering and nutrient-processing function. The wetlands shown here at sunset on the Raritan offer a picture of what the river once was, and could be again, as people silently clean its waters and protect its wildlife. (Courtesy of the Raritan Riverkeeper.)

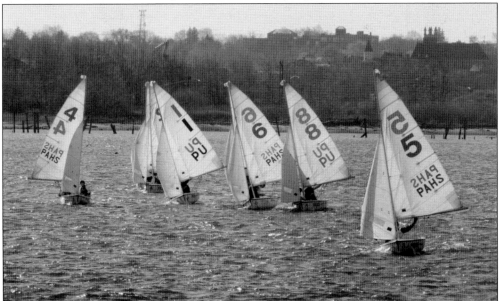

Sailing has returned to Perth Amboy, and the Perth Amboy High School sailing team is now a regular sight on the bay. They are seen here practicing with the Princeton University team. Sailing, once an understood part of the education of any young man living in the port city, is now available to the young men and women of Perth Amboy, after decades of being halted by pollution. (Courtesy of the Raritan Riverkeeper.)

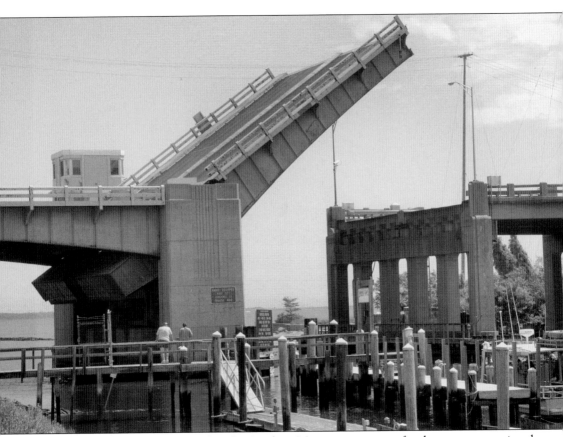

The Route 35 bridge over Cheesequake Creek in Morgan now opens for the many recreational boats that use the marina here. Once the site of clay mining and, during World War I, the T.A. Gillespie Shell Loading Plant, which exploded in 1918, the creek is now a recreational area enjoyed by boaters from throughout the region. (Courtesy of Verne James.)

The jetty at Morgan guides boaters to and from Cheesequake Creek, where they enjoy grand views of the Raritan Bay. From here, the Verrazano-Narrows Bridge, the longest bridge span in the Americas, is seen rising over Staten Island. (Courtesy of Verne James.)

The beaches at the mouth of the Raritan River now enjoy the cleanest water in generations. This view of the Great Beds Lighthouse from Morgan Beach shows no signs of industry. The beach and the waters in this image appear much as they did when the lighthouse was built, when visitors in the late 19th century came here seeking the clean waters and fresh air of the bay. (Courtesy of Verne James.)

In the postindustrial Raritan River, fishing is once again a viable source of recreation. As pollution has abated and a number of dams have been removed above New Brunswick, American shad and eel, in addition to other species that once called the river home, are now returning. The Raritan once again provides a vehicle for fish migration. (Courtesy of the Raritan Riverkeeper.)

The appearance of other sea life, such as turtles, is a welcome sign to environmentalists and fishermen alike. Whales and dolphins have returned to the bay, which indicates that food is abundant enough for them to follow it into the waters of the Raritan. The river is undoubtedly coming back to life. (Courtesy of Verne James.)

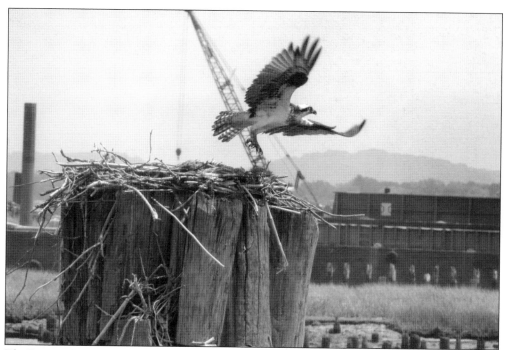

The Raritan River is the natural habitat of many bird species, notably ospreys, herons, bald eagles, and peregrine falcons. This osprey is just one of a growing number who now call the Raritan home. Their diet consists exclusively of fish, so their proliferation is a great indicator of healthy fish populations, which means healthy waters. (Courtesy of the Raritan Riverkeeper.)

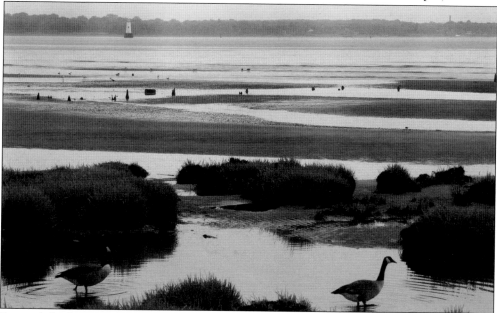

Primarily herbivores, these Canadian geese are enjoying the wetlands along the Raritan Bay in Morgan. A recently preserved area of beach and wetlands here provides these migratory birds with a quality environment in which to feed and rest. Preserved areas such as these are crucial to the continued recovery of the river and the bay. (Courtesy of Verne James.)

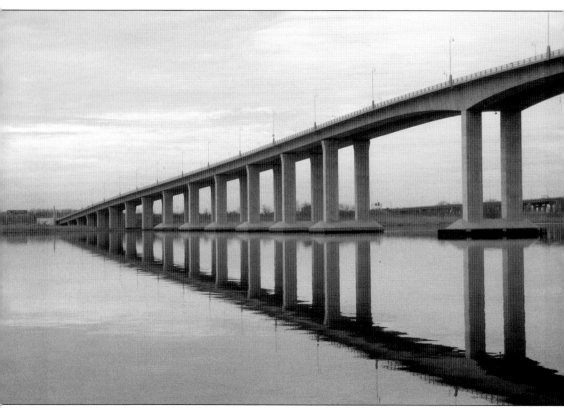

Completed in December 2005 at a cost of $109 million, a new Victory Bridge replaced the aging 1926 steel swing span bridge, which was subsequently demolished. The new bridge, actually a pair of twin bridges, spans high above the river, ending the traffic delays experienced on the old bridge when the swing span was opened. With both a sidewalk and a bike lane, the new Victory Bridge is the first bridge over the lower Raritan River to accommodate cyclists and pedestrians, offering magnificent views of the Raritan Bay and the Edison and Driscoll Bridges. The new bridge is better suited to the changing landscape of the river, allowing residents to experience the grandeur of the Raritan from outside of the confines of an automobile, just as communities along the river have reclaimed the riverfront so that their citizens can once again enjoy the sights and sounds of the mighty Raritan, "Queen of Rivers." (Courtesy of the Raritan Riverkeeper.)

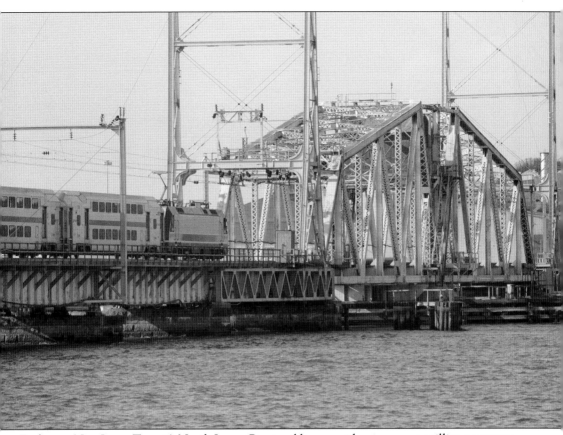

Each year, New Jersey Transit's North Jersey Coast rail line provides over seven million passenger trips. Here, at the last bridge before the Raritan spills into the Atlantic, the busy rail line quietly crosses the Raritan. In 1915, John C. Van Dyke wrote from New Brunswick that "there is a River running eastward to the sea—a gentle little River of still waters that reflect, and shallow rapids that run in lines of amethyst, and slow-moving tides that flood and ebb without a ripple and without a sound. It is only a commonplace River—so commonplace that the millions who rattle over its railway bridges in express trains hardly put down their newspapers to look at it. Its history is purely local and it never was grand enough for romance. No one has written it down in deathless verse or painted it on immortal canvas. Art, science, history, philosophy have all passed it by. In fact, it has been left quite alone save for the life and the love of the people who have lived by its banks and watched it through the years slowly drifting to the sea." (Courtesy of Verne James.)

DISCOVER THOUSANDS OF LOCAL HISTORY BOOKS
FEATURING MILLIONS OF VINTAGE IMAGES

Arcadia Publishing, the leading local history publisher in the United States, is committed to making history accessible and meaningful through publishing books that celebrate and preserve the heritage of America's people and places.

Find more books like this at
www.arcadiapublishing.com

Search for your hometown history, your old stomping grounds, and even your favorite sports team.